Other Reflexes

Other Reflexes

by Diana Georgiou

Book Works

For the boundless and ever-expanding universe who goes by the name Natalia Damigou-Papoti

PRELUDE

Do you remember the sound of our click? It was September and I was fresh back in London after having spent a very difficult summer on the island. You had escaped your own homeland and that in itself was the first step to all the dreams that you wanted to materialise. We met at work, during a month-long production with a film studio. I was instantly drawn to you, as was everyone who met you. You had that alluring type of quirky and witty humour that caught people's attention. When you spoke with someone, you made that person feel completely heard, supported, special and unique. I wondered who could ever reciprocate all the attention you were able to deliver. Your powers of reasoning were arresting, but you would dampen your razor-sharp intelligence out of fear that it would intimidate people. The desperation with which you sought connection, even at the sacrifice of the most outstanding characteristics of who you truly are, terrified me. At the same time, it was precisely this ability of yours that linked us together as, within a few days, it became clear that we were both impostors.

You said yes to everything, you cared for everyone's wellbeing, listened to every complaint and attended to every caprice. You went out of your way to appease the director's tantrums, the makeup artist's boredom, the cast and their competing egos. You were hired as a runner, but you surpassed every expectation. I pretended to know what I was doing as the producer's assistant. I was fully aware that my role involved the performance

of self-assurance, even though this was not explicitly noted in the job description. I asked for things in debonair fashion. I gave out instructions and expected everyone to execute the tasks straight away, in the order that I asked for them, on behalf of the producer, even though the organisational sequence rarely had any logic. I mediated between the producer and the crew as though I were a foreign relations diplomat, trying to secure peace by making both parties believe that they were getting their own way. I wielded charm, wit, tact, barter, seduction and, if none of these worked, I used outright manipulation or control. I hated myself a little for the latter but then I would repeat the producer's threat in my head: 'If you can't do it, just don't come to work tomorrow. I'll find someone else. It only takes one phone call.'

Months later you told me that you were outside the office and overheard the conversation. That you felt like you should do something, but you didn't know what. You resorted to lingering around long after everyone else had left, and I lingered around you hoping that you would invite me for a drink. Instead you offered to help me tidy up the set; you made a habit of doing that almost every night. Within a short span of time, we became so perceptive of each other's presence that we heard the unspoken words in the awkward silences; we heard the meaning even if it contradicted the things we said; I heard your heart pounding when we were alone in the elevator; you heard me catch my breath when you put your arm around my waist for that group photo. I listened so carefully that, the morning before our final shift together, I woke up at 4 am because I was certain that I heard you calling my name.

That morning I went to work early and was up on a ladder replacing a light bulb when, out of the window, I saw a middle-aged man drop you off in his car. I rushed to the lobby, hoping to catch you by the coffee machine for a chat. Archie the receptionist beat me to it. He pranced over to the revolving door to help you with the half-dozen prop bags that you were carrying, and asked, 'Treating yourself to a taxi on your last day?' To which you replied, 'No no, that was just my fiancé.' Just. I shrank away from the coffee counter towards the lift, and made my way undetected back up to the studio. A few minutes later you walked in with your usual cheerful performance and, when our eyes met, I knew that you hadn't slept all night. We used to listen to each other then.

The shoot was finally over and we were the only people left to clear up the set. You removed everything from the technician's toolbox and then proceeded to put each item back in perfect order. That's when you told me your story. You exceeded yourself and I attended to your every word, every teardrop, every sigh, while you divulged your history and all the painful realisations that came with it. You clicked the toolbox closed and said, 'It's done now. All the mess has been cleared up in here. Thank you for listening to me.' You tidied up your past into a neat, linear story and sealed it inside that box. I was certain that the contents would overflow and find us again sometime in the future. The past doesn't end with a new beginning, no matter how much possibility the present circumstances engender, no matter how deep the connection between people. And so, in due time, it all spilled over.

You have been gone for nine weeks now. I think of our last night together in our home, where we have been living for just over two years. You packed a slight rucksack, and I hoped the slightness was an indication that you would return soon. The last thing you said to me was, 'I'm not coming back until we can start listening to each other again.'

I'm outside on our tiny balcony, sitting on that wobbly chair we found on the street that Monday when we ran home after a dance class in the pouring rain. I am observing the moss that has propagated in the balcony corners, and I put its removal on my to-do list for the weekend. I am smoking and drinking Turkish coffee, a ritual that transports me back and forth through all the escapades I have ever lived and those that I have imagined living. I think of my life running parallel to yours, as a series of crossings in different geographies and time zones until, one day, our paths also crossed. We traversed seas, continents, cultures and classes in search of conditions where we could finally be heard. I left behind the noises, the people, the habits, the fears, while you brought everything with you, including the fiancé for a while.

We had both made a habit of escaping when things got tough, albeit for very different reasons. For me, this time, there is nowhere else that I would rather be than right here, on this balcony, in our home, watching the squirrels in the oak tree and thinking about the moss. From the flat below ours, I can smell Nisha's mouth-watering Haleem — stewing for the last hour — arriving at my nostrils mixed with the usual neighbourhood whiff of cannabis. I want you to know that our Alocasia

plant has survived London's interminable winter and I've managed to get round to putting up that extra shelf you wanted by your desk, so when you return you can move your books there. The mould in the bathroom came back, as it did last year, and the landlord took two months to sort it out. Your mother sent you a package with the usual herbs and teas, and she rang to ask if we'd received them. I told her we had; I don't think she could tell that I was crying because she continued telling me about the linen pillowcases that she was making for us. My mother wants to speak to you every time she calls, but I keep telling her that you are having a hard time at work and that you will get in touch as soon as the project comes to an end. Jay bought some new motorcycle gear, and got hold of one of those vintage leather jackets you wanted to wear on that bike trip that we have been planning for so many months now. I hope that these stories will reach you in time for that trip.

Our cat is purring against my shin; I lift her onto my lap. She spends more time outdoors since you left. As I run my fingers through her fur, I remember the sensation of caressing the undercut on the back of your head and I close my eyes as a way to intensify the feeling. I think back to the sound of our click. The moment you fastened the toolbox, you looked up at me and our eyes locked. I leaned over, grabbed the darned thing by its handle and said, 'Let's get this out of the way then.' You placed your hand on mine and replied, 'That's my job. I'll do it when I'm ready.' And while I knew exactly what you meant, I was too fixated on your hand on mine to let that sentence sink in. *When I'm ready*, suffused the atmosphere and spiralled around our bodies even

when you interlocked your fingers with mine. *When I'm ready*, seemed to be at complete odds with the way you lifted me onto the makeup table and I had to clasp the back of your neck to steady myself as if I were steering a raft in a tempest. Like a hungry naiad your mouth thundered between my thighs, I licked my lips and got drunk on the saltwater of my own tears, rocking in and out of consciousness, a deep connection with every single molecule that composes the world, my body dismembered and dismantled, yet perfectly intact in its concession to your rapture. I made love to every single species, every living organism and the energies that survive living, and wept tears of having delivered the world both inside and outside me. I spilled and streamed and washed all over us like a baptism, a new name, a new beginning, this is a new life, what does *when I'm ready* mean when you are calling out my name, your fingers inside you, your tongue inside me, torrents torrenting and we latch onto each other in a flooded room holding onto that precious thing life.

The latch of the toolbox bulged at me like the scorching eye of an octopus. I retaliated with all my myths and superstitions and hissed at it, 'Quiet now. Become a talisman, Pandora's box or blue eye, ward off the evil or keep it locked inside, don't look at me like she isn't ready. Is this not enough proof?' I pointed down at the heavenly mass that spilled down her thighs, inundating the entire room with our sex.

That was the first time that all my senses came to make sense in a present moment, an experience so consuming in its totality and effect that it brought me to my knees. I couldn't yet fully embrace how my

body was able to completely match an experience both emotionally and physically, across contexts and circumstances, eventually from the private to the public sphere; at times, I thought I would collapse from the weight of such a compelling encounter. Of course things would get difficult between us. While you are in the process of gradually shedding the layers of your history, I have been trying to recuperate my senses, to restore the years of damage across every physical register, to sustain the wholesomeness that I touch but cannot always withstand when I am with you.

For us to start listening to each other, I will have to give you a biography of the senses, a detailed explanation of how my faculties were slowly distorted. I hope that through these stories I will be able to explain to you why my relationship to listening is a little strained, why it is that, when things get a little difficult, my impulse is to run away from it all. And yet, it is you who ran, not I. When you read this, I want you to know that I am here, waiting to listen to everything you have to tell me, *when you're ready*, of course.

SONIC MEMORIES

Did I ever tell you that I am a little deaf? My left ear is more tuned up than my right. This is the ear I sleep on to shut the world out. It is the one that I press the handset against when I pick up the phone. The ear that I always extend to spy on secret talk, the one that I first pierced at the helix, the left ear that once leaned over to meet your lips in a noisy room.

Did I ever tell you that I used to be afraid of the dark? Mum would have to sit patiently by my side or pretend to sleep so that I could doze off. When she snuck out, she would make sure that the door was half open so that a triangle of light lit up our floor. Triangles of light still make me feel safe. We slept together until I was nine. Rather, I slept, while she guarded my dreams. I don't ever remember her sleeping.

A window in the bedroom, as far as I can recall, would always have to be slightly open and never covered. To this day, this little detail follows me through the hundreds of rooms I have slept in. I developed an aversion to curtains, low ceilings, thick fabrics, clothes, tights — restraining and swaddling things. I cultivated a passion for transparent, light and delicate goods, like filo pastry and lace, porcelain tea cups and crystal ashtrays. But this is not what you need to know. As one of my first lessons in perseverance, I refined my ability to block out certain sounds by becoming more of a reader than a listener. While such a conversion shouldn't ordinarily be of concern, it is nonetheless the reason

for where you and I find ourselves. Let me tell you what I remember; memories from before I made myself selectively deaf.

With the night window about three inches ajar, I could feel that outside my room the world was still reassuringly in motion. Late at night, in such a small town, all you might hear would be the occasional car, the neighbours taking out the trash, the odd couple speaking in hushed tones on their way home from a restaurant. Pigeons would rest between the rooftops cooing gossip to one another, and bats would swing into the trees like acrobats somersaulting onto a luscious banquet. The cats were always the highlight of my evenings. They made me laugh and, if I wasn't too sleepy, I would jump to the window, watch their spiky backs, and feel my own nape hairs prick up at their shrill and throaty threats when they fought over the contents of the garbage cans. Only later did I find out that this was the preliminary sound to what most often ended in savage copulation. These few sounds were enough for me to know that all was as it should be in the world outside. These sounds also signalled that the morning would soon arrive, and with it the buzzing that I longed to hear. There was no danger in sleeping if I could hear even the faint humming of the day in the darkness and stillness of the night.

Morning. The tempo slowly rising. Cars and trucks revving up their engines at the crack of dawn have long held a place on my roster of comforting sounds. We didn't have trains. The reverie of endless distance and escape which they evoke was something that could not

be experienced on this island. Instead, there were lots of cars in almost suffocating proximity. Right outside the window, first thing in the morning, I would wake to the commotion of kids rushing in and out of their houses, toppling their school bags onto leather car seats. I could hear the soprano commands of mothers while their husbands growled, *pamen* (*let's go*) in Cypriot dialect with their every cigarette exhalation. These were familiar sounds, even though I never experienced them in my own family — my mother never drove and I rarely saw my father before midday. But Mum did walk me to pre-school or, even better, she would sit me on the back rack of her bicycle while she pedalled all the way there. I vividly recall this acoustic journey, my tiny shape so close to the crackling of earth under tyres — twigs and stones colliding with durable rubber. The hiss of air around every corner swept my hair to one side to reveal and tickle the shell of my ear. Like a friendly serpent it whispered an elongated 's' — imagine the tip of your tongue meeting the back of your two front teeth to pronounce the word 'hiss'. The cranking of the chain with every pedal-push spiked the skin of my naked forearms with its squealing complaint. Bikes were all made of heavy steel back then. They produced sounds that I have associated with joyful journeys and discoveries: heavy yet high-pitched rhythms; solid yet airborne. This contradictory combination of heavy and high was a cadence I came to recognise as the acoustics of familiarity. I often mistook familiarity for safety.

My mother always got off the bike in the same aerodynamic way. She would twist the lower part of her body to the left and, while pressing the brakes on the

handlebars, glide her butt off the saddle and bring it all — herself, the bike, the bags in the front basket and little me on the back rack — to a halt. This gymnastic sequence required two and a half calculated steps, with a longer pause after the first step and no pause between the second and last step, before coming to a complete standstill with feet firmly on the ground. The sounds produced by this stunt were very specific: left step — right step/sharp left step. That's how I always get off my bike now: Pattt — pat/pt.

Pattt — pat/pt is how I used to bounce my basketball when I walked to school. Only that it sounded more like thuddd — thud/thd, and on repeat. This is what daily life sounded like during fifth form. By then I had already been going to school mainly on foot and by myself. The cars and the dribbling thuds kept me company as there really wasn't much else to hear for most of my daily routine there and back. It was within the high walls of our all-girls Catholic school that I became acquainted with the distinctive echo of automated order and discipline: the lethargic assembling of elastic ankles and sleepy knees on a concrete courtyard; the singing of holy songs blending with clandestine giggles. The latter being the sound that I came to understand as excitement. I often confused excitement with risk.

Inside the classrooms you could hear chalk sticks scratching and tapping on a blackboard, like a form of Morse code striving to inscribe information onto our memory. First as sound, then as text, lastly as knowledge. The rapid turning of lost pages and lost minds. I remember the sound more than the knowledge. I remember how scroll-length poems were forgotten as soon as they

were recited, and what remained was the feeling of forced attention. Soon enough, I understood that the outdated knowledge we were provided with was not the type that could inform our varied and unique experiences. Neither did it have the same acoustic quality as the dialect we were versed in, nor that of the foreign languages we gravitated towards. It was not until a few years later that I came across the first noise that would unmistakably be the sound of truth.

High school. Our ascent to knowledge came with a move to a room on a higher floor. It was as though our enlightenment had to follow all sorts of lofty and hierarchical ideals, including the architectural setting that we were educated in. Aside from the feudal wooden desks and stiff chairs, our room had nothing else in it but a freestanding metal bookcase right at the back. The top half of the bookcase had glass doors, the bottom half sliding metal doors that were always locked. A selection of *National Geographic* magazines from the 1980s had sunk down to the bottom shelf of the glass section; some classic literary works — the likes of Dickens, Shakespeare and the Brontës — occupied the middle shelf; and an array of bibles, hymn books and a picture of the Madonna sat on the top shelf. Indeed, when it came to the composition of knowledge, hierarchies seemed to exist everywhere. Looking down, I felt my ears flush when I spotted the keyhole of this bookcase. Between the slit of the locked metal doors, I could see the faint outline of more stacked books. I was excited by the prospect of exposing all that the nuns

had been suppressing. They had judged entire sentences worthy of detention but, strangely, not elimination.

I went home that day and rummaged through my mother's dressing table. The sound of glass, plastics and metals of different weights smacking against each other still reminds me of the rituals my mother conducted before going out to work in the evening. Hairbrushes, rollers, combs. Powders and tiny square jars of dusty colours refused to be contained in their little casings and protested by smudging the sides of the wooden drawers. Body lotions, perfumes, face creams, lubes in tubes filled with never-to-be-fulfilled promises of everlasting youth. Slapping the items from left to right, I sifted for the hairpins that lay at the bottom of all the promises. I had seen how demonic pins committed criminal acts on television. I had also seen people open a door with brute force, but it seemed evident to me that very little could be gained by force. My initiation into criminal knowledge was established with the aid of these hairpins. Then came the paper clips, the metal coat hangers, and all sorts of wires to satisfy the desires of an outlaw's dreams.

I practised on the front door of our flat. It was a task which required precision and attentive repetition. I bent a hairpin into an 'L' and slid one end into the dentures of the keyhole with an exacting fondle that composed a minute jingle. By performing this metallic flossing, I was able to locate the denticles that awaited probing. I listened to where my pick was grating or jangling, and hoped to hear the ping that would mean it had struck the correct fang. I imagined these sounds as a musical score sheet with specific points of notation. The aim was to hit all the notes at once and use another pin to rotate

them with one swift anti-clockwise movement. Knowledge might be hierarchical, but most truths are located by way of anti.

That's when it happened. The first meaningful sound I came across was the click of that door. All clicks are followed by a bang. The bang is not always audible. It's an internal, gut sensation that feels like a space has been hollowed out following a huge release. Most of us have experienced this click at least once in our lifetimes, even if it is impossible to remember it: the first bang arrives after our entry into the world, following the shutter-like click of the collapsed lips that delivered us. But we are all susceptible to forgetting where we came from, despite the majestic bang that follows and hollows.

Once I had noticed the sound of that type of click, I could no longer mistake it for anything else, and I started to remember all the others. The first bottle of cider I tasted at the snooker club, clicked open by Johnny the bartender with his teeth; the Zippo lighter that was nervously clicking and flicking in the fingers of the first boy I longed to kiss; the click of the wrist preceding the sort of handshake that seals an unspoken agreement for all eternity. This one is followed by a different bang. It's more like the sound that spills over after a wave has slammed into a rock. Click! Bang-Shhhh. The click of the latch of a public toilet. The first time Mario clicked my jeans open. Isabella's clicking heels while crossing the Millennium Bridge, announcing a universe full of celestial bangs. The last phone call, which ends with the type of click that almost hollows out the very movement of time. That morning when I woke up with your head resting on my belly, you told me that,

prior to that moment, everything had felt like one big lie — an internal bang so audible that I had to place my palm on my belly to ensure I hadn't been mysteriously shot. The click of my front door was just the beginning of a symphony of gut truths.

The next day at school I waited for the lunch break, when everyone else would be outside. Jay kept guard. We had already clicked a handshake a few years back. I took the hairpins out of my hair and started to operate inside the bookcase's lock, producing sounds of a miniscule surgical intervention. When I found the artery, I aligned the rest of the organs and gently rotated the 'I' into a dash. Click — bang.

Jay started to sing 'Born Bad' by Juliette Lewis to signal that someone was walking down the corridor. I grabbed the first book that caught my eye and slid it into my panties. It stayed there for the next two hours while I tried to concentrate throughout our French class. When the lesson finished, I hobbled to the toilets and removed the book. The title read, *Les Mots*. The act of stealing men's words and desacralising them against my core is something that I am still inclined to do today.

Words came to transform my relationship to sound. It was a gradual process. It started with the ability to read — and I mean reading in the broadest sense. From reading words and the stories that they string together, to interpreting images or deciphering the codes of conduct around me. Simple readings, like trying to fill in the shapes of a colouring book according to the visuality that surrounds us. One reads the smiles of people one

encounters, and in time discovers that a curled lip is not always an indication of pleasure. We read words that at first sound foreign, and sentences which seem so long that, halfway through, we return to the start in an attempt to reassemble their meaning. I recall sleepy breakfast sessions that consisted of pronouncing every word on the milk carton and cereal box. Mysterious contents comprised of numbers and letters, long parenthetical words with many vowels, and no explanation of what they all meant. From slogans proclaiming a sonic-oral experience — 'snap, crackle, pop' — to assertions that consuming the contents would fortify our little frames with a tiger's stamina. This habit then made its way into daily experience almost compulsively. Reading the contents of shampoo bottles promising 'no more tears'; marketing flyers for must-have household items stamped with a seductive white font on red circles trumpeting the word 'SALE'; spotting every error on a bilingual menu; unfolding the meticulously pleated paper wrapped around the pain-killers, reading the horrific things that they could induce, and painstakingly refolding this opaque compilation of side effects to fit perfectly back into the box. What else could you do with an overabundance of youthful attention and no significant interlocution? By the time I reached high school, I was already able to sit in the noisiest place, in the most uncomfortable position, and ingest words so voraciously that they created a pulsating, protective cocoon around me. Reading became a habit. But for those of us who were raised in worlds where our persistent efforts to read were constantly met with contradictory meanings, reading became a pathology.

I know that my father used to beat my mother, even though I rarely saw this happen with my own eyes. I may perhaps recall one or two occasions, but they are so blurred in my memory that it is difficult to distinguish how much of this dreamlike sequence was real, and which parts of it were fabricated in my then untainted mind. How can I best explain this to you? It is as though the events that I witnessed, with the frantic and convoluted feelings they unexpectedly whipped up, could not match anything else that took place in the rest of my daily experience. Vision and sound — and, for the purposes of what you need to hear about, let's restrict this to sound — did not correlate with any human expression that I could comprehend. So, whatever it is that I saw, I had certainly developed a mechanism that could eradicate the image of it, or, out of pure disbelief, animate it into something that seemed less threatening. Somehow, my parents managed to keep these matters predominantly locked out of sight, but certainly not out of sound. The sounds were another realm.

My mother would rush me into the living room, switch the TV on, kiss me on the lips and, without saying a word, close the door behind her. It is interesting how at that age we are more attuned to non-verbal agreements. But the TV offered no consolation as, whether I wanted to or not, my ears would prick up in concentration to discern if the situation was over, if my mother was safe, if dad was still at home, if they were really fighting or making love or if they were simply talking. I don't think I remember them ever talking to each other. This feeling of prolonged uncertainty, produced by the agonising effort it took to interpret unusual and muffled sounds,

preoccupied me so much that I struggled to sit still
and allow the very ordinary moving images on the TV
to divert my attention. When I got a little older, around
the age of seven, I would run outside and away from
the sounds that came out of their room. I would meet
the neighbourhood kids and join in with any collective
pastime that was going on, whether it was sports,
building houses out of boxes, or theft and vandalism.
Such activities offered a temporary distraction from the
sounds and enabled me to move towards pursuits that
required a different type of mental process: the ability to
think with the aim of winning; to calculate in order not
to get caught; to plan, draw and execute according to
something beyond myself, preferably for the benefit of a
group. In adult terms this can be understood as activism,
charity, football, organised crime, religion, politics.
A dear friend once told me that most of these ventures
are socially endorsed outlets to subdue control issues
or to replace an addiction; obsessive and compulsive
behaviours that surface out of a broken belief system.
We used to chain-smoke every time we talked.

But before I could go outside, there was that inter-
minable period in our home with sealed doors and ears
alert. I had a collection of comic books with so many
captivating stories, which I would reread when their
bedroom door closed. I escaped into these humorous
adventures, where there was always a happy ending
regardless of the apparent catastrophes that the protago-
nists endured. Every happy ending felt exhilarating at
first, but once it ended, and the noises went on without
end, I had to pick up the next story right away. Like
a temporary fix, I sank into the stories, hoping that at

some point, if I too, just like the protagonists, managed to endure, the sounds would stop. But, soon enough, the effect of the happy stories started to fade when I learnt them by memory, almost word for word.

It was my mother's books that then came to my rescue. To this day, I don't know if she ever read any of them, but she certainly looked at the images because there were oil paint smudges and superimposed sketches of her own work inside them. I came across melting clocks and boundless landscapes, women carved out of triangular layers, violins that trilled the sounds of floating alphabets. I recognised some of those elements in my mother's paintings. I still have faint recollections of the magnificent worlds she used to conjure, as only a handful of these survived my father's wrath. While she depicted surreal fragments of her painful reality, he destroyed not only the evidence of her experience, but also the process by which she supported herself through the experience. My mother's paintings and the images in those books filled me with the kind of fascination that exists outside ordinary life. In due course, that's how I came to perceive the world. A sense of time slipping away while I existed on overlapping geometrical planes. Where my experiences felt like colours melting into each other, ambivalent shapes that aroused a series of emotions, which kept on trying to suppress or release ideas with some logical effect. With my mother's paintings vanishing shortly after they came to life, it was her books which provided me with a space that was consistent, magical and hopeful through years that were permeated with unpredictability and imperma-nence. They contained visual landscapes that I was able

to read with more than one meaning and without any contradictions. These images were able to capture the complexity of life in ways that were not only meaningful, but almost necessary to survival.

However, her books were in English and the majority of the words were unknown to me, so that, even when I turned the letters over in my mouth or pronounced them out loud, they didn't make any sense. But that didn't seem to matter, since I had found that images could provide me with a sense-making system for those moments which crystallised out of a kaleidoscope of perceptions. I would become transfixed by a picture, gorgonised by the myriad stories it was trying to communicate, to the point where words would just emerge from me. What I didn't know then is that, if one of the senses becomes compromised, the rest will start to alter as a way to strike a new balance. While I was starting to numb my ability to listen, reading came to the fore as the main means by which I could gain a sense of equilibrium in a very dissonant world. Entire paragraphs framed these black and white images in a grid-like order and, lacking the right reading tools, I made up my own interpretations of what they could mean, what stories they were telling and, most significantly, what futures they could unfold.

And that's when I stopped hearing the sounds from the bedroom once and for all. When I started to use my own words, my own voice out loud, louder than the sounds, to recount the magnificent things that I could see. Things that escaped the banality of everyday experience, paintings so sensational that they could transform the pain and horror into slices of beauty waiting to be recomposed into wholesome visions of a parallel reality.

Indeed, I desired to live in a world where such a reality could be made manifest, and if I couldn't paint this other reality, I would use narration to recreate it.

It is remarkable how these little events stay with you, unadulterated, for the rest of your life. Looking at those images had the power to transport me away from the sounds that I did not want to hear. They took me to such fearless places in my mind, I was certain that one day they really would take me, and my mother, out of there too. Eventually, they would also lead me to you.

GOOD TASTE

It is not that I didn't like my cousin Eleni; it's just that we were so very different. As the only two girls amongst a dozen grandchildren, it was assumed, rather simplistically, by our foreign mothers and the rest of the blue-blooded Cypriot family, that in time we would grow increasingly fond of each other. This was a somewhat strange assumption considering that my mother and Eleni's mother, two women who were new to the family, also had fundamental and irreconcilable differences. The difference between Eleni and me was obvious from a very young age, and it had to do with the lack of that most important bond between children: a mutual understanding of the realm of imagination and what constitutes leisure.

I was attracted to the outdoors, to physical challenges and collective activities. But I was also mesmerised by the peculiar settings that the neighbourhood women created in their gatherings. They would sit on rush bottom chairs around a table laden with bowls of pea pods waiting for their butts to be nipped. The women's hand movements became so automated, you would be hypnotised if you observed them for too long. An adjacent table would be strewn with dishes of various delights, and there would always be that bittersweet, lingering smell of brewed coffee. As the custom had it, if you were given a dish on your way out, you had to return the serving plate full, and so it was rarely the case that a woman would turn up at another's home empty-handed. When they took breaks,

they sat around the overturned coffee cups containing their muddy hieroglyphs, which could only be decrypted by women whose common denominator seemed to me to be their excessive amount of jewellery. They foretold the fate or serendipity of times to come, but also engaged in stories about their past, their current affairs or the lives of others, whether living or dead. I would spend hours pottering around in their company, hoping I would get to listen in on some of these extraordinary tales.

Instead, Eleni wanted to play with toys that I found incomprehensible. Chunky plastic dolls in the shape of infants with uncanny, blinking eyes; empty dollhouses with eerie rooms and numerous baby cots — which I thought were supermarket trolleys that had lost their wheels; tiny tables waiting to be decorated with even tinier flower-patterned teacups, which I had only ever seen in black and white American films. There was a similarly patterned thing that you were supposed to fill with liquid to pour into the cups. Eleni told me that this was a teapot. I didn't believe her because we only ever drank Grandma's tea when we were sick and, even then, it was poured from a round stainless-steel pot and not this eggshell vessel. Eleni's bedroom was filled with miniatures of domesticity which resembled none of the items that we could see in our family's homes, and so I decided to begin an investigation.

To solve the enigma of the teapot, I took it to my grandmother to verify what it was. She said it was an English toy. I asked her how one was supposed to play with it. She said that it's not for us but for English people, and then handed me two smooth, flat, black beach stones and a bowl of almonds. 'Play with this,' she

said, with her dark blue eyes smiling at me. I spent that afternoon sitting on the floor with my legs spread into a V shape and the black stones between them. I placed an almond on one of the stones, right on the centre, and, with this sophisticated tool in my small hand, used all the strength I had to smash the shell, taking great care not to break the seed, or my fingers, into a pulp.

Grandma used the almonds to prepare some *kalon praman*, which literally translates as *good thing*. This recipe, like much of our mysterious cuisine, called for an intricate process of combination and exclusion. The *good thing* had a long history of travels, gathering many stories along the way. Grandma's version of the chronicles of the *good thing* began with the Egyptians inventing the recipe more than 2000 years ago. In fact, to her husband's dismay, most of Grandma's accounts were rooted in Egypt, without any clear reason for her convictions. Her Persian friend Leila, being the only Middle Eastern woman who regularly had coffee with Grandma, found herself confronted by both my grandfather and the locals to corroborate many of Grandma's fables. But as much as Leila insisted that she wasn't the source of these myths, recounting once again the differences between her homeland and Egypt, the locals remained sceptical about anything she said. This meant that everything she traded also came under scrutiny. She struggled to sell her vast array of imported one hundred per cent Egyptian cotton towels because they were now marked by the mystery of the Egyptian myths that Grandma was spreading. Her clients couldn't understand whether Leila was lying about her geographical origins, the origin of her merchandise, or the origins of the

stories in Grandma's head. The shoppers would ask her if the towels were genuinely made in Egypt, and some even asked if they were really one hundred per cent cotton. She spent more time trying to answer such questions than elaborating on the details of her fine fabrics.

Late one afternoon, Mr. Costas the butcher popped into Leila's shop for some curtains. Influenced by the gossip that had reached his ears, he coyly asked why she didn't import Persian carpets, since that is where she came from.

'Because I left for many reasons, and I will not go back just for carpets,' Leila replied, irritated.

'There is more money here, *ennen*?' (*Isn't it*), Mr. Costas said, and winked at her. 'That's why you came to Cyprus.'

'You know very well that my husband and I were making more money in Iran as architects! Now he works on a construction site six days a week, and we would be lucky to draw one plan every few months. Architecture doesn't pay the bills here Mr. Costas, these towels do.'

There was a long pause. In such a small town, Leila felt that privacy was no longer possible. Everyone seemed to know everything about everyone, so she was surprised that Mr. Costas looked taken aback. Nevertheless, he pressed on with his questions, albeit in a more light-hearted tone after seeing how unsettled Leila had become by his curiosity.

'My sister-in-law said that your friend is telling people that our *kalon praman* was made in your country.'

'No! She is convinced that the dessert was originally invented in ancient Egypt.'

'Well, isn't that where Persia used to be?'

Leila looked at him with indignation and could not understand what all this questioning was about. What did he want to hear that would satisfy him? Was she supposed to agree with everything he said? Would that put an end to the questions? It seemed that, no matter what she tried to do to set the record straight, the replies she gave would be carried away to some place where they would be twisted and stretched, and then return to her shop completely warped by someone else's mouth. No matter how cautious she was with her answers, no matter what she replied, it would always come back to bite her.

'Yes Mr. Costas, the Persians conquered Egypt for about a century, more than 2000 years ago. Do you know that they then conquered Cyprus? Maybe the *good thing* is actually Persian and not Egyptian.'

Mr. Costas looked at her like a small child who had just been presented with something incredibly exciting. Pleased with her response, he smiled at her and said, 'You are a very intelligent woman, Leila. Very intelligent. *Tsakmatzin!*'

Leila couldn't have known that the last expression is drawn from the Turkish word *çakmak*, which means a cigarette lighter and was used in Cypriot dialect to describe someone who is quick-witted. Mr. Costas left her some money on the counter for the curtains and walked out quite elated.

That night, Leila told her husband about her meeting with the butcher, and the various local women who came into her shop and gave her suspicious looks. Her husband told her to consult with Mostafa, an Egyptian

who ran the biggest souvenir shop by the old port. Mostafa is married to Maria, a shrewd businesswoman who is the descendant of one of a handful of families who started trading in Egypt in the early twentieth century. Her family was known for popularising the Venetian-style embroidery called *Lefkaritika*, a type of linen so laborious in its detailed patterns that large pieces, such as a bedspread, could take a couple of years to produce. Maria's parents couldn't oppose her marriage to Mostafa as his family was one of their biggest clients. The couple married in Alexandria but, with political tensions building toward what would be the Egyptian revolution of the 1950s, they emigrated to Cyprus shortly after their wedding, to avoid the conflict. They set up several successful businesses, and Mostafa seemed to be respected by the locals and treated as though he were one of them.

'That old woman has become a nightmare for me, Mostafa. Don't get me wrong, she has welcomed me into her home when many others haven't, and I truly respect her for her generosity, and for introducing me to her family and the local customs when we first arrived. But she has some eccentricities you know,' Leila said, looking to Mostafa for a nod of agreement.

'Most of her sons have a thing for European women or they travel abroad getting up to monkey business, so she is used to being surrounded by foreigners and shady deals. But unlike them, she is an honest woman and she means well,' Mostafa assured her.

'I agree with you, but people come into the shop and they ask me about her crazy stories and they scrutinise my products. They somehow think that I am

putting things in her head about the ancient Egyptians, and when they want to buy something it seems like they think I am trying to cheat them. I am so honest with them, I tell them the truth regarding all my products, about the very little profit I make from each item — I even tell them to check with the merchants I buy the products from. You know, one of them is your relative, Mr. Barakat in Alexandria; he speaks very well of you.'

'Of course he does. If it weren't for my wife's brains and business, he would be nothing but a camel driver. But how can I help you, Leila?'

'I don't really know. I thought, maybe you could tell these people about Egypt. They don't know the difference between Egypt and Iran. Most of them haven't gone to high school! We came here for a better future but this place is so backward, they don't even have a university on the island where we could at least do some teaching. I told my husband that we should try to leave for France or England. It's all so difficult here.'

'I can tell them about Egypt, but I doubt that will change anything. I don't think you have understood how things work here. You and your husband are foreigners. Whatever you do, they will still think that you are trying to cheat them and, in my experience, telling the truth will not make a difference.'

'You are also a foreigner, yet they have such a high opinion of you,' she said with narrowed eyes.

'I am married to Maria. They respect her, not me. It also took years for them to really believe that I was not trying to cheat her whole family. But more than thirty years have passed since then, and we have had three children, so I think they changed their minds at last.'

'I don't have thirty years, Mostafa. I have thirty days every month, and each of those days I pray that we will make enough money to pay for our expenses. The tourists here are my best clients, but the summer season is now coming to an end and I will have to find a way to sell more to the locals.'

Mostafa felt her desperation and, to put her mind at rest, he said, 'Look, once a week I take the old woman rosewater and coffee from our shop. I can speak to her and see if she can do something about this situation. After all, she is the one with the crazy stories. You know, it's not many families here that welcome foreigners like us, and if this is part of her eccentricity then I think it is a good quality.'

Leila was put slightly at ease by his suggestion and said, 'Thank you. I pray that something will work.'

Every Friday, Mostafa did the afternoon deliveries and left his eldest son Ali to look after the shop. Grandma was always his last customer. He would arrive punctually at 4 pm with his most refined products, and he always stayed for an hour. Grandma's front door was customarily left open in the afternoon to welcome anyone in for a coffee, or for us grandchildren to be able to come and go. But on Fridays, with Mostafa's visit, the door would close.

'You are making trouble for Leila with all your stories,' Mostafa said with a grin on his face, as he carried the groceries to the kitchen counter.

'They are not my stories *re lafazani*, they are yours!' she retorted, calling him a fibber in dialect as she started to unpack the goods. Mostafa approached her from behind and placed his hands on her hips.

'*Habibti*, you don't have to tell everyone about the things we say in private.' Calling her *my love* in Arabic, he gave her a kiss on the neck.

'One day I will tell them about the things we do in private Mostafa, and no one will believe me.'

'Why do you say this *habibti*? You know it's better to keep this to ourselves. Your husband does his own business, so you should behave like a free woman too. If he finds out about us things will not be good. He will try to kill me for sure, and Maria will throw me out.'

'I know I know,' she said fretfully, 'I'm just tired of all this. All week I care for five children, nine grandchildren and one *pezevengi* (*cuckold*). What do I get in return? Nothing! All I have is one hour a week where I forget about them all. At last that hour comes, and the first thing you tell me is about Leila and her problems. I don't want to care about anyone else's problems when I'm with you.'

'People are already talking because you close the front door every time I come. We will have to do something. Maybe you should tell them that it's me telling you the stories and not Leila. This way they will think we are having conversations and not anything else. Even better, why don't you tell them that we are trying to matchmake my son Ali with your youngest daughter — that would really remove any suspicion.'

Grandma softened, and understood that they would have to come up with some story if they were to continue seeing each other. 'You know that my youngest daughter has a few loose screws. She will probably never marry or have kids. Your son will suffer if we get them together.'

Mostafa laughed and said adoringly, 'Yes, but she has some of your spirit and look how little I suffer when I see you.'

This put half a smile on Grandma's face, and she agreed to take part in his scheme. They spent that hour together and, on his way out, Mostafa said, 'I see your daughter almost every day with that little blonde girl, but I never see your son walking around with her, you know, like a father should do once in a while. It seems your daughter loves her very much, so maybe she does want children of her own.'

Grandma smiled and, opening the front door, she replied, 'I also love the girl; in fact, she is my favourite grandchild. But it doesn't mean that I wanted five children or all these grandchildren. Your son better be careful, because my daughter will leave him in a heartbeat if he thinks that she will stay at home and raise his kids. The women in this family have always yearned for more interesting lives, even though the fates decided otherwise.'

I was sitting on the doorstep that day, waiting for the door to open. When Mostafa came out of the door he picked me up in his strong arms and said, 'We were just talking about you *ya helwa* (*my beautiful*), and how much your aunty loves you. It is certain that your destiny will be different! The coffee cups say so too.' He then spoke softly: 'Don't believe all of your grandmother's stories or you will go a bit crazy.'

Grandma never laughed and rarely did I see her smile, but on this occasion she gave Mostafa a crooked grin and I saw her golden canine tooth.

Despite the trouble she was creating, Grandma was one of Leila's most faithful clients and, following her conversation with Mostafa, she decided that she would set the record straight. On matters of local culture people would follow her lead, so she gradually managed to convince all the neighbourhood women to invest in Leila's textiles. The women who trusted Grandma did so on account of her cooking. She was the authority on local cuisine for at least three parallel streets either side of her house. And if anyone expressed uncertainty about any of her instructions or ingredients, a single bite from one of her dishes would suffice to banish any doubt. And so, when she eventually told people that she had long conversations with Mostafa about the origins of their gastronomy, the *kalon praman* became known to the neighbourhood as an Egyptian, and not a Turkish, dessert.

By many of the Turkophobic nationalists of the time, this version of the story was gladly received. In turn, as the locals couldn't trust Leila's words, Grandma repeated them and, through her mouth, they became facts. She told them that Mr. Barakat, a relative of Mostafa, was Leila's main trader. That Leila was an honest woman and barely made any profit, that the products were all high quality and definitely one hundred per cent cotton. Within a few weeks, the locals were flocking to her shop. Whether the occasion was simply some new bedding, or a gift for a nephew's wedding, the ceremonials for a grandchild's baptism and the handkerchiefs to wipe up all the tears; whatever the purpose or whim, Leila came to define the aesthetic of our generation.

After his conversation with Leila, Mr. Costas was going around boasting that he had cracked the riddle of the *kalon praman*, declaring that it was, in fact, an ancient Persian sweet. Grandma took a while to convince him. She spent one whole afternoon recounting the same story that she told the local women, peppered with as much detail as possible. She reasoned with him that, since the Egyptians were capable of erecting pyramids thousands of years ago, they would certainly have built a large oven to feed all the hungry people who laboured on their construction. She insisted that the Egyptian recipe was as old as time but only came to be perfected in the capital of Syria, Damascus, where the local secret ingredient was said to be an exquisitely distilled rosewater. When the recipe travelled to Izmir in Turkey, the rosewater had to be replaced with the most refined equivalent, which, during the nineteenth century, could only be mastic. Worth its weight in gold and blood, the people of the Greek island Chios worked all year round to provide the Sultan with the precious resin in the hope that their lives would be spared. The couple of thousand people who survived the massacre under the Ottoman rule went on to produce what would become a staple ingredient in many desserts to this day. The dessert was renamed *şambalı*, which means *Damascus honey*, and from there it made its way to Greece, where it became known as *samali*.

'Our recipe is Greek!' Eleni announced triumphantly when she heard Grandma telling Mr. Costas the story.

'No Eleni, the Greeks use mastic, but we don't,' Grandma said patiently.

'Then the cake is Turkish!' she declared, again almost certain that there were no other options.

'No my dear, we don't put any peanuts in our recipe.'

'Well then it can only be Syrian! We said all the other places.'

'Certainly not! Our rosewater is good, but it's not as good as the one from Damascus, and that's why we use orange blossom water or geranium leaves instead.'

'I don't understand. Was it the Egyptians that brought it here?'

'Most probably it was them. Doesn't that make more sense to you Costas? Even our little Eleni understands this,' she said incontestably.

This roundabout form of storytelling never led to any satisfactory conclusion because Grandma had a habit of spinning tales to suit her own needs. If Greeks were visiting our home, they would try to claim the dessert as their own, so Grandma would compose the story from another thread to somehow trace its journey first to Cyprus and then Greece. Just over a decade had elapsed since the messy, bloody and odious affair of 1974, which saw a Greek coup d'état and a Turkish military invasion play out within days of each other at the expense of the locals. With motives which are still unclear, and that resulted in the island being divided into Muslims in the north and Orthodox people in the south, the general sentiment in the south where I was raised was that Cypriots are so Greek that they are direct descendants of Alexander the Great, while Turks are depraved barbarians who invaded the most beautiful and wealthiest parts of the island. Greeks visiting from the continent shared this belief, as they still carried the generational grievance of having lost the city of Constantinople to the Ottomans hundreds of years ago.

Grandma wouldn't have any of that and this made her quite an exception to the majority. We could tell which Greek visitors she was fond of from the way she would ask them how they drank their coffee. It was one of her most brilliant performances, perfected to the smallest of gestures. The Greek guests would arrive, she would feign an exuberant welcome, kissing and hugging them, smiling broadly and making them feel comfortable right away by taking their shopping bags to the dining room, telling them where to sit, lowering the radio to the perfect volume for background noise and, just when she had them relaxing into that cosy abandonment, she would say in thick Cypriot dialect, 'I will bring you some *good thing*!' to which they would exclaim 'Good!' in delight. It was at that very moment that she would ask, midway through turning to walk out to the kitchen, 'And how do you drink your Turkish coffee?' The Greek visitors would be left confused; some would respond instantaneously, and then slowly realise that she had said Turkish and not Greek. Some would mull over the event long after they had gone, trying to figure out whether they had heard right.

As we were so young, the visitors talked as though we weren't there, and so Eleni and I always heard what they said behind Grandma's back. Once they were gone, we would report everything word for word.

'Akis asked his wife if you are a communist!' I diligently attested. 'What's a communist?'

'It's what your mum's family is,' she replied.

'Grandma, Katerina said that you have been acting strange since Grandad started horning you. What does it mean to horn?' Eleni asked naively.

'It means that your grandad spends more time with goats than with his family.'

'Can we go and horn with the goats too? I love going to the farm!' Eleni said gleefully.

'Not now. But don't worry, when you grow up, you'll get your share of horning too.'

This circuitous and riddling type of communication seems to have been adopted by the whole family, so that, at every dinner conversation, I always felt that nothing that my relatives ever said had any real beginning or end. Stories would twist and turn to suit the occasion, depending on which visitor was listening, and what we sought to extrapolate from them. Conversation would often lead to red cheeks and quavering voices competing on the level of sound rather than rhetoric. Perhaps this is why there was always some syrupy semolina and almond baked *good thing* lying around. It helped to keep their mouths occupied; to sweeten hoarse throats and sour faces; to make them pause and take turns in speaking. I kept my mouth shut throughout these tournaments and, even when I grew up, I knew it was better to just eat the cake.

Years later, in one of the grey metropolises that I lived in but never really became acclimatised to, I called Aunty, the official gatekeeper of all of Grandma's recipes, to tell me how to make the *good thing*. Her first reaction was one of pleasant surprise. She then scolded me, saying that it would be impossible to find the right ingredients. I assured her that Turkish merchants nearby stocked some of the finest products.

'What merchants? Mostafa's son? He is a crook just like his father. You know he sells Egyptian products in London and claims they are Turkish? Bloody *lafazanis*, I should have never married him, even if it was only for six months. And thank god for that abortion, otherwise I would still be stuck with the *pezevengi*. Don't buy anything from him. Well, maybe the rosewater. Your grandma always used a dash of Mostafa's rosewater, even if the recipe didn't call for it.'

She continued to rant, just like Grandma used to, and told me off for assuming that any of the products in London would be of high quality. Twenty minutes later, after endless huffing and puffing, and after insisting that almonds had to be bought in their shells and not blanched, she gave up and explained the process to me, in minute detail. It took almost an hour to extract all the particulars of this seemingly simple bake, which included the zest from both lemons and bitter oranges. I thanked her and said that I suspected Grandma's recipe had its own unique ingredients, referring to the zest.

'Don't be silly,' she said, 'that's how it's always been made, probably since the times of the pyramids.'

She must have heard me trying to suppress a giggle, and so I promptly reassured her that I would prepare it according to her very strict guidance, and that I would try my best to make it as good as Grandma's.

'You might have all the ingredients there, but they will certainly not be fresh or in season. There are no almonds in January! And even if it were the right time of year, you still can't make the recipe!'

At this point I had to laugh out loud. 'For the love of pyramids, Aunty,' I implored, 'tell me what is missing

and I promise you that I won't make the recipe until I find it!'

'You don't have the stones!' she cried out. 'If you had come back for the holidays, like normal people do, then you could have borrowed the stones and smashed some fresh almonds.'

This was her way of telling me that I should visit her soon.

FINAL TOUCHES

His eyes behind horn-rimmed glasses felt like slippery eels sliding against my skin. If you have ever swum with eels, you might understand what it feels like to concentrate so hard on staying afloat while the feeling of overbearing repulsion is drowning you with the weight of an incomprehensible panic, terror, disgust. You rationalise the repulsion. It's just an eel. An animal. Another living entity completely unaware of how its existence can be the locus of someone else's torment. After all, the eel belongs to the waters. It reigns there in the company of other eels, surrounded by its own dangers. I had no business being where I was; in fact, my intrusion into those waters could easily be interpreted as asking for trouble. In the same way, when I showed up at his studio, on a late Friday afternoon, I knew that I was way out of my depth.

I did not know of any female photographer on the island. Expecting, at the age of fifteen, with all the fragile rebellion that many of us bore during our adolescence, to be treated as something other than a woman (a girl), was quite a demand to make of this eel-like man. One man, among many, in the field of photography. Like all disciplines deemed of value, and which entail payment for intellectual or creative labour, this too was a sphere in which only men could take part. I was not interested in paid labour; I was interested in technique. The price I paid for technique makes every photograph I will ever take priceless.

'My mother's friend Svetlana said that you are looking for an assistant,' I said politely but confidently, and in formal Greek rather than dialect. (Do not disturb the eel waters.)

'Yes. Kind of. Mainly Saturdays, as that's when I shoot weddings and baptisms. Someone to watch the shop while I'm out on those jobs. Maybe someone who speaks good English and can talk to the tourists who pop in. Sweeping and mopping the floors when we open, and taking payments too. Can you balance a till? Have you done that before? I can't pay you much, business is slow until the summer.' (You look like you would make a good shop assistant.)

'I'm sure I can do that. I speak English quite well, and other languages too. I'm good at maths so the till won't be a problem. Maybe you can teach me how to take photographs, since you can't pay me much.' (I'm worth more than you and your entire family will ever be.)

'How old are you?' (Eel assessments.)

'Seventeen.' (Fifteen going on sixteen.)

'You're a bit young to be looking for a job… And you don't have any experience. I don't think any other photographer would hire you, so for the first month I won't pay you until you pick up the skills.' (Poor little foreign girl.)

'You're a bit too old not to have money. Are the other photographers better than you?' (Don't panic.)

He was sitting on a high stool, peering into the viewfinder of the minilab photo printer, when I said this. He moved his head back, still looking straight ahead without blinking, took his glasses off with his right hand and drew his left hand inside his trouser belt to untuck

his man-blue XL t-shirt. He started to rub his glasses into the bottom of the curled-up fabric, revealing a swell of hairy, pale fat underneath. He blinked but still did not look at me, and said, 'Come back tomorrow. You'll work for free for the next two Saturdays; as I don't have any jobs booked I'll be able to train you. If we get along you will work every Saturday from ten to six, for twenty pounds a day. I'll show you how to process and print film because you will have to do that for the customers. I don't have time to teach you how to take photographs, but you can use the stuff here to practise. Don't take any equipment outside the shop. You can use two films a week, not more. One colour and one black and white.'

'Great! I look forward to seeing you tomorrow at ten!' I said enthusiastically, and rushed out of the shop.

I met Jay at the old port and, with the sunset behind us, we walked out to that part of the coast where a handful of makeshift shacks were set up as workshops for repairing boats. A shabby cabin cruiser was perched on some rusty oil barrels and we helped each other climb up on the deck. We broke into the little wheelhouse and examined the controls and various items that must have been lying around for months. Empty beer bottles, a fire extinguisher and a life jacket, a pair of tracksuits and a small radio which, surprisingly, worked. It was a tight space and, with the crackling sound of the radio, it was the perfect set to spark a celebration.

'So, you got the job. Here's to you becoming a great photographer!' Jay popped the lid of the beer bottle using the butt of a lighter and handed it over.

'It's a little too soon for that, Jay. And there is something about this guy that makes my skin crawl.'

'He's just a man.' A phrase that I have been hearing from her lips for a couple of years now, and which seems to clot with additional disgust each time she says it.

'You can kind of tell what men are thinking when they stare at us, as it's always the same kind of gaze. But this was different, Jay. He gave me a very strange look when I walked in, and after he realised what I was after, he didn't look at me again. It was weird.'

'That *is* weird. For a photographer especially. Do you think he's gay?'

'No. I don't know how to explain it. I felt like a little girl and not a woman. Like I was small. Not physically, but emotionally. I felt vulnerable and unprotected and aggressive at the same time. But he didn't really do anything to make me feel that way.'

Jay was listening to me attentively, but at this point her expression transformed from concentration to endearment.

'Oh wow… That explains why you have always been a little braver than me. All this time you felt like a woman.'

I looked at her, trying to decipher whether her dimples carried a hint of irony or a trace of pleasure. 'What do you mean, Jay?'

'Men never look at us or any other woman as if we are women. In their minds all women are girls unless they are grandmothers or spinsters — then they don't look at them at all.'

I laughed at this observation. A laugh that harboured a blend of amusement and unease. I wondered what this meant in relation to all the men who typically looked at my mother, a woman (or a girl?) who was now nearing

her mid-forties with a lot of grace but an equal measure of ineluctable self-loathing. I knew that I would do anything not to feel as she did. I found myself drawn to older women who seemed weathered by time yet timeless in their vibrancy. Like Rosa, my aunty's friend, who always wore a combination of black, red and gold, and whose long hennaed curly hair was given a good rustle every half an hour, chiming with the bangles that snaked up her arm. Rosa would just appear in Aunty's living room, almost out of nowhere, when the atmosphere was dense with dilemma. I remember her always seated in the single armchair, with legs spread open to accommodate a long black skirt hanging down the middle of her voluptuous thighs, revealing her fiery-red manicured toenails which perfectly matched the colour of her lips. When Rosa smoked, it was as if she had the ability to slow down time, making you observe even the minutest details of your surroundings. I noticed the fine lines that would form at the top of her red lips when they pursed around her short black and gold cigarette holder. Her ochre-stained index and middle fingers that formed a scissor-shaped grip. The shaft of sunlight entering the front door that sliced through the cigarette smoke to create the form of a luminous arrow on the wall. I caught sight of two houseflies that lazily meandered through the smoke from door to door without ever leaving the room. And the tiny yellow pistil of a jasmine cutting in a glass of water, placed by the crystal ashtray that Rosa was using. She was usually holding a coffee cup in the ladle of her hand, delivering its mysteries with her husky breath. When Rosa would smile at me, three gold teeth on the left side of her mouth beamed

a warmth right into my tummy that made me laugh uncontrollably. My reaction would prompt her to laugh too, a roaring laughter that made the wrinkles on her face swirl around like an animated Van Gogh painting. I loved Rosa with all the innocence and admiration that children experience at the sight of people who contain the fullness of life written on their faces. I wanted to be a Rosa when I grew up.

'I guess it's nice to think that even when we get old we will still feel like girls and that people can relate to us that way too,' I said, with black and gold on my mind.

'That's not the point,' Jay said, 'the point is that if men perceive us as girls, then that makes them all paedophiles.'

The local gay bar was not exactly cheap, but we always managed to drink all night, whether we had lots of money or none at all. Tucked away in a narrow cobblestoned alley by the Turkish hammam in the old town, we would go without any expectations, even though we were all driven there by the same desire. The proximity to sex was better than no sex at all. In retrospect, perhaps it wasn't about having sex; it was more about sexuality in general — ours and that of others. Although it was a Friday night, this didn't mean much in terms of what would be happening or who would be there, save for the owner, a retired flight attendant who once travelled the world but who was now always behind the bar. It was around midnight and fairly quiet, with the usual crowd of older gay men, young "straight" boys with crewcut hair who were just starting their mandatory military service,

a couple of taxi drivers, Pambos the transvestite, and Jimmy who was gay, deaf, speech-impaired, highly intelligent and witty, and habitually bullied because of all these attributes. His hot pink marathon shorts also made him a target for homophobic insults or catcalling at the local cruising area, but still he wore them with pride. Yet the older generations treated him like the town mascot, offering him free coffees or food, and some even thought his presence at their shop to be lucky. Such paradoxes defined the experience of all those of us whose sexuality or gender deviated from the norm. That is, the very few of us who were either forced, or who dared, to be visible.

The bar started to heave with bodies entering one by one through the sixteenth-century wooden door. Several middle-aged lesbians, whom we recognised as clerks from the local post office, the central bank and the Italian ice cream shop (which, surprisingly, was run exclusively by women). A group of British tourists flaunting gay semiotics: an earring on the left lobe, a bandana around the neck, a leather waistcoat, symbols that made them stand out from the rest of the unkempt crowd. But then Mariza walked in, wearing a flamboyant black, sparkly, low-cut dress and stripper heels. Pambos lit up with delight and the soldiers squirmed in their seats. She butterflied from the lap of the taxi driver to the DJ deck, circumnavigating the bar tables and pinching, both in appreciation and in jest, every fleshy protrusion she could find: an exposed love handle, the strong arms of the leather daddy, the slick neck of a "chicken", the silicone breast implants of the sex workers who had just finished their shift. Everybody knew, and to some extent warmed to, Mariza, even those who didn't really accept

transgender people. She was also the daughter of one of the wealthiest families on the island, and that guaranteed that no one would actually mess with her eyeball to eyeball. In the general run of things, it was her BMW that fell victim to the unspoken threats and slurs, which were scratched into its jet-black veneer.

Jay and I sat around a high table by the stage, enjoying the KEO beers sent over by some unknown admirers — we tried to suss out whether it was the soldiers or the lesbians. By word of mouth, we had found out that the Orthodox church owned more than half of the shares in the KEO business, as well as numerous other highly profitable and occasionally unlawful enterprises. Not only was the church entangled in all affairs of state and business, they interfered with every aspect of our daily lives, including what we did with our bodies. We thought that not buying their products was one way to erode their power, but it soon became obvious that it made no difference to the immense influence that they exerted. So, this code of conduct acted more as an unspoken agreement between us, or a visible statement of our position, which was applied regardless of our spiritual inclination. Apart from the bar owner, that is, whose inclination to make money overrode most codes of conduct. And so, we deduced that the beers couldn't have been sent over by the lesbians. Jay then winked at one of the soldiers in the hope that more drinks would come our way.

In this small space, with the windows always shut to protect us from prying eyes, the atmosphere dripped with bodily vapours and a potpourri of essences that I now recognise as the haze of illicit lust: cigarette smoke, alcohol, sweat, sour breath, peanuts, urine, used latex,

leather, the waxy-rosy scent of lipstick; strong taxi driver cologne competing with prostitute *parfum*; deodorants that smelled like fresh laundry; the folks who worked in the local catering industry, who would turn up smelling like an English breakfast sprayed with cheap aftershave. Airless spaces and breathless faces with so many variations of desire it was hard to tell which one was your own.

Like a tougher version of Cicciolina, Mariza's voice blazoned, 'Welcome to paradise, my flower buds!' When she grabbed the microphone, we all knew that some impromptu act was imminent. Pambos approached her with utter glee and, by her side, a foot shorter and wider, he pouted at us all and clasped his hands together, his satin gloves almost bursting at the seams. I have observed those same adorable chubby hands grilling our food at the local taverna for so many years now. At work he normally wore a white vest, but tonight his hairy chest was protruding from a strapless, heart-shaped dress whose cleavage was stuffed with unknown and uneven material. When he smiled, you could see his pink lipstick cracking around the edges and his left fake eyelash drooping a little. To me he was the most beautiful cook in town, and I always wondered how someone so gentle, convivial and kind never became the material of sexual fantasies.

'You can't get off on someone like Pambos!' Jay shouted, just as the music stopped. She realised that this might have been too loud and looked around hoping no one had heard. 'He's too nice. You want to do it with someone you hate a little.' Just then Pambos blew her a kiss while tugging at his huge blonde wig, and Jay responded with an exaggerated, 'I love you, Bambina!'

'Who adores Aliki Vougiouklaki?' Mariza hollered and the crowd cheered. 'You! English faggots at the back… do you know Vougiouklaki?' The tourists, who seemed accustomed to such snarky remarks, chuckled in delight. 'You *don't* know Vougiouklaki! Because you are ignorant English homos who don't speak any other language. Aliki is our goddess! The goddess of faggots, dykes and transsexuals like me. You have Madonna, we have Aliki! Tonight you will hear Aliki and you will love her!'

Pambos was abruptly handed the microphone and, still a little startled, he said in broken English, 'Welcome everyone! So nice to see you. I sing now very famous song in Greek. Many singer make this song in their language. For us, is Aliki who make this song famous. Let's go, Mariza!'

The all too familiar tune of 'Big Spender' started to crackle out of the speakers. Pambos had his back towards us on the small stage and we could just make out some clumsy hand movements. Offbeat and off-tempo, he turned and blew glitter from his palms over the audience. Like an inflated, sugar-coated, over-decorated doughnut, he sprinkled us with his joy and, terrible as his voice was, he made up for it with his under-rehearsed but bold dancing.

'I really love the guy but I cannot bear to listen to him!' Jay said, just when his voice was breaking at the crescendo of the refrain, 'Hey Big Spender'. I noticed how some customers discreetly plugged their ears. As I was looking around, suddenly the lights and music shut off with a loud clank. Complete darkness in our cave. I started to make out the faint outline of Jay's kindled cigarette, suspended in the ashtray. I then felt a breath

on my neck and a pair of large hands on each side of my waist. They squeezed a little before making their way towards my bellybutton. So elegant in their command, I could do nothing but surrender to their sensual authority — even when they slowly went under the buckle of my belt, my lips parted expectantly, my eyelids slumped and trembled in anticipation of the promised sensations.

'I used to have a waistline like yours when I was a little girl,' Mariza whispered in my ear, and I let out a breath that fused arousal and confusion. The lights came back on. It was the usual trip switch dropping from too much amperage. With her torso and full breasts still glued to my back and her arms around me, she cupped my tits and screeched at the crowd, 'This is not what you think! I'm innocent!' She then teetered towards the stage, swiping a cocktail from someone's table and, plucking the mic out of Pambos's hand, she said, 'Your voice broke the sound system, darling. Stick to your day job.'

Everyone laughed, Pambos included, and a small group chanted, 'We want more! Break it again!' cheering him on.

'And now something for our international guests!' Mariza exclaimed. I started to make out the sultry drum and bass of 'Human Nature' by Madonna, and, with 'express yourself, don't repress yourself' gaining in the background, I wondered where Jay was. Hips were already starting to sway at the back of the room and a crowd grew around the bar. Jay wasn't hard to spot with her crewcut hair, bright red lipstick and large hoops. Entangled in the bodies by the counter, what I noticed first was her hand, sporting the leather spike-studded cuff I had given her for her birthday the year before. She was squeezing a butt clad in light denim boot-cut

trousers. The butt belonged to one of the soldiers. The one she hated a little.

The alarm beeped for what felt like a second, and it was Jay slamming down on the device on my bedside table that actually woke me up. I got up to shower off the musk from the bar, as I drifted in and out of the previous night, recalling Mariza's hands and trying to pull myself together for my first shift. The shop was thirty minutes on foot. I stopped by the bakery for coffee and food. My back moist from the brisk walk, I arrived promptly for 10 am to find the doors of the shop still closed. I waited on the front steps. Twenty minutes later and still no sign. I walked around the building, thinking that there must be a parking lot where he would arrive. It was nearing eleven and I started to have palpitations, not knowing what to do and anxious that he'd stood me up. I rolled a cigarette and decided that I would wait until 11:15, and if he didn't turn up, I would just leave.

Still sitting on the front step, I heard a set of keys clattering inside the shop. It was him, probably entering from some back entrance that I'd missed when circling the building. He opened the front door and said, 'Come in, through to the back.' No good morning, no apology for being late, no offer of a drink after letting me wait around in the heat. I followed him past the bulky equip-ment, the sour odour of something like a mix of vinegar and urine gaining in strength.

'What's that smell?' I asked, not knowing that this was the effluvium of acetic acid, a chemical used as a stop bath during film processing.

'You'll get used to it,' he replied bluntly.

This is the phrase. The variations of physical intensities that this phrase produces in me, the layers of painful emotions unfurling, one by one, like deflated parachutes dropping from the sky; they pile up into a monument of injustice lodged in my throat. I never got used to it. Twenty years of learning and teaching photography cannot obliterate the association I have formed between the sour smell of stop bath and that phrase. When my students now ask me the very same question as we enter a darkroom to process black and white film, I tell them that it is the smell of 'arrested development.' No one gets used to it; they just learn to tolerate it.

'Unload the van and take the equipment to the front counter. I have to go to a photoshoot out of town, so we need to get this ready in an hour.'

I did as he said. Moved every bag to the counter, removed every single item from its designated case, and examined them according to his requirements. Light bulbs, batteries, lenses, strobes and umbrellas, cameras and video cameras, checked for functionality, repacked, and loaded back into the van. He demonstrated how to remove a film from a camera and how to load a new one. Lesson one completed.

He then showed me a stack of Kodak photo envelopes with handwritten names and telephone numbers on them. 'These are the orders that are supposed to be picked up today, but they don't always come to collect them. The price is written at the bottom. Take the money and put it in the till. If new customers come in, take their films and jot down their name and telephone number. Tell them they will be ready on Tuesday.'

'Where's the till?' I asked, looking around.

He pointed at a small tin box that looked more like a paperweight, sitting on top of a pile of letters, documents, photographs and magazines. I opened it, and there was a set of keys inside and a handful of coins.

'What if the customers need change?' I asked, perplexed.

'Tell them there's a kiosk next door. Don't let anyone take away their order unless they have paid. You can sweep and mop the floor at the end of the day, as we are already late opening. Take the keys in the till to lock up when you leave, and drop the keys through the letter box. I'll see you next week.' Just as he was about to walk out of the door, the phone rang. He came back to answer it and spoke so directly that he sounded almost angry. 'Yes, next Saturday I'm free. A half-day shoot costs £100. Three rolls of film processed and printed at a size of five by seven inches. I keep the negatives and you keep the prints. Any enlargements or copies will cost you the standard print price.' He hung up the phone, jotted something down and said, 'You better be here next week. I just booked another job.'

In the six hours that followed I had two visitors that both showed up during the first hour. They were both surprised to find me sitting behind the counter. Neither of them had change. I was deeply apologetic, claiming that we had had quite a few customers who had already taken all our change, even offering to pop to the kiosk myself. When they left I examined the space, opened all the drawers, looked into the dusty glass vitrines filled with frames and photographic samples that had probably been printed a decade ago. The place was a mess. The

toilet was a makeshift darkroom that reeked of chemicals and certainly hadn't been cleaned in years. I decided that, if I was going to be using it, I had to do something about it.

There were no cleaning gloves, or even disposable ones for the chemicals. In the one-person kitchenette I found a sponge that looked like it'd gone through hell, a mop that had turned from yellow to brown, a broom that was having a really bad hair day, and no sign of any cleaning product other than an inch of watered-down washing up liquid. I locked up for a few minutes, took some money from the till, and bought supplies from the kiosk. I left a handwritten note in the front window telling customers to ring the doorbell and undertook a deep clean that lasted three hours. With an hour left before closing time, I checked out the odd bits of photographic equipment scattered in the most unlikely spaces. I found stacks of film in a box under the counter. I took one colour and one black and white film, and tossed them into my bag. I decided to count all the films in the shop. Just in case. I balanced the till by writing down the amounts received on a piece of paper, and put this in the tin along with the receipt for the cleaning products. I mopped the floor and, on my way out, took two more black and white films, then locked up. 'Asshole tax,' I thought to myself.

When I arrived home, Mum had already left for work. I felt like I could smell the shop all over me, so I showered again and got ready to meet Jay at the cafe where her sister Tina waitressed. When I turned up, Tina waved at me from behind the counter and, by the time I'd found a spot to settle in, she was bringing over a tray

with coffee and a toasted sandwich, on the house. She told me that Jay was seeing someone about a motorbike, and would be back soon. I read the local paper, ate, skimmed some of the fashion magazines lying around, chatted with acquaintances, and noticed that a couple of hours had passed. Tina brought me a beer without me asking for one, and blurted out, 'Where the hell is she again? I really don't know how you can wait around for her like this. Don't you get worried? I'm worried. She said she was just going around the corner.'

'Jay's always like that, Tina. She's probably hustling someone, or maybe she bumped into friends.'

'Friends? What friends? You're here!' We both laughed.

'Anyway, how was last night? Did you see anyone we know? Did you get into trouble? Jay hasn't told me anything yet. She didn't even call in at home, so I had to make up stories for our parents. I told them that after staying the night at yours, you both came here to do some homework and then you went to the beach, so keep that in mind in case you see them.'

Tina was always covering our asses. She did that so often that keeping track of the lies became second nature. At that moment, Jay walked in wearing the same clothes from last night. She hugged her sister, kissed me on the lips and said, 'Guess what I got us?'

I smiled but Tina interrupted the moment with, 'Are you going out again? You haven't even been home since yesterday! Call Mum and Dad before you go, otherwise they'll ring the cafe again.'

Jay dropped a set of keys onto the table and instructed, 'It's the red one outside. Take it and meet

me at the back exit of the cafe, the one that leads to the kitchen storeroom. Leave your backpack here.' She picked up my backpack and went behind the counter to make a phone call, before disappearing into the kitchen. Outside the cafe there were a dozen motorbikes and a single shiny red Vespa from the 1970s. I drove round the block to get to the storeroom. Jay was outside with my backpack, which now looked twice its size. She jumped on the back and said, 'To Lady's Mile beach: the girls are having a party.'

On the way there, she told me about her day. She had woken up in my house around midday, and had a chat with my mother. She then called the soldier from the night before, whose name she still couldn't remember. She met him at his parents' house and they made out a little. He then said that he really wanted her to join him and some friends at a beach party out of town. Jay said that she had a friend's birthday dinner to go to and would love to join him after that, but her motorbike had broken down and she wouldn't be able to catch a ride with anyone, as they would probably all want to stay at the dinner. She then persuaded him to let her borrow his bike, so that she could definitely meet him.

'Did you have sex with him?' I asked.

'No! I didn't even have to,' she said, giggling.

'I'm surprised. He's the first one who hasn't tried.'

'Of course he tried! But I told him I'm a virgin, when he started to get a bit too fired up.'

'Didn't he then say, "maybe we can do it from behind"?'

'Of course he did. But then I told him, "I would only do that with a boyfriend. Do you want to be my

boyfriend?" and obviously he got a bit funny. But he's still keen. I gave him a hand job and he came in two minutes.'

As we approached the seafront we detected a faint light. We could hear music blasting out of Georgia's jeep, and when we noticed Milena's racing bike we hoped that her obnoxious husband wasn't there too. Jay dropped my backpack by the bamboo lamp burning paraffin oil, and unzipped it to reveal half a dozen spirits and a couple of beers. Sitting around the flickering light, we spoke mainly about Milena's family, who were caught up in the Yugoslav Wars. Her parents arranged for her to leave as soon as she finished high school. At the tender age of eighteen, she found herself in Cyprus with a husband, visa problems and only cash-in-hand work, hoping that her paperwork would come through so that she could get a regular job. Even though Georgia, at the age of twenty-two, was the eldest of us all, we somehow felt that Milena possessed a maturity which set her apart, so most of us would seek her out for advice on practical and worldly matters. Georgia and Milena were part-time lovers; everyone knew except the husband, who was employed at the same gas station as Georgia. Jay occasionally got it on with Georgia when Milena was not around. Everyone knew this too, including Milena and her husband. He had gone camping that morning with his mates, so we knew that that night — before Milena's freedom expired with his arrival home the next day — would be lived with all the stops pulled out, right up to the last minute. We heard a couple of motorbikes in the distance and lowered the music, just in case they meant trouble. It turned out to be a couple of girls from our

basketball team, Georgia's ex-girlfriend Sofia, who was visiting from Greece, and some acquaintances who'd heard about the gathering. Jay broadcasted to the group that I was going to become a 'great photographer', which prompted several rounds of tequila shots. Until it was time to make our way, once again, to the gay bar.

We arrived at 2 am and it was almost empty. There was a peculiar hetero-looking couple sitting at the bar, trying to suss out what our group was about. We occupied some tables in the corner, ordered beers, and the owner let us take over the DJ booth. An hour later people started to enter in swarms and, tired of supervising the music, I put on *Now That's What I Call Music! 1994* and let it run.

Sofia was telling me about the booming gay and lesbian scenes in Athens, where she had just started her undergraduate studies. I grew envious, and my body tensed with anger thinking about the cops who ambushed the cruising areas just for their sadistic pleasure; a sadism born out of repressed desire; a cruel injustice made possible by the very legal system from which we expected justice. In Greece, homosexuality had been decriminalised in the 1950s. However, under Section 171 of the outmoded English colonial criminal code, retained by Cyprus on becoming an independent republic in 1960, homosexuality between men was treated as 'an unnatural offence', punishable by up to five years' imprisonment. This gave the police free rein to abuse homosexual men. Since homosexuality between women wasn't even acknowledged by the judicial system, lesbians remained invisible unless they interfered with male affairs, such as their wives, sisters and daughters. In those

circumstances, the law offered us little protection; it was clear that messing with male assets could lead you to end up dead. No one that we knew of had gone to jail, nor did we know of anyone who was murdered because of their sexuality. But we knew of broken bones, black eyes and bruises, ostracisation, intimidation, rape and sexual assault, deportation if you were foreign, sometimes a combination of all of the above. Sofia explained that all of this was ongoing in Greece too, despite the law and the flourishing scenes. It seemed that our disparate worlds were only able to (co)exist if they ran parallel to each other, without the slightest crossover.

Growing up on an island where your first experiences of desire come weighted with criminal associations is — what's the word I'm looking for? — complicated. You realise something that most people will not ever come to experience, let alone understand, because they live and die under a sun that has their best heterosexual (and, almost without exception, male) interests in mind. You realise that the law is, simply put, wrong. You question everything. You participate in daily life with one foot in regular social interaction, and the other foot in spaces where you can be yourself amongst other criminals. You know that you are breaking the law, but you also know that you are right and the law is wrong. You are a criminal anyway, so it no longer matters what laws you break, and you find solace in the company of criminals of many kinds, from illegal migrants and sex workers, to those who steal to support their families or their substance addictions, to the countless women who have aborted illegally, to artists who depict nudity, which can supposedly corrupt one's morals; the list goes on.

You do not, and will not ever, belong in a country where the legal system refuses you and your criminal fellows justice. Life will be a perpetual negotiation between being a fugitive and wanting to finally go home. Whatever utopian idea of home exists in your mind, the only time you have ever felt a sense of home is when you are in the company of other criminals.

I was startled by a tap on my shoulder, as if I'd been busted for communicating these thoughts to Sofia, and, when I turned, I had in front of me the female component of the heterosexual couple. She asked if I would play a track for her. I told her that I would show her the mixing equipment and she could put on whatever she wanted. Behind the decks she tried to engage me in casual conversation, but I had a suspicion that it wasn't about the music at all. She asked me how old I was and where I was from, presuming that I was a foreigner, even though we were talking to each other in dialect. I lied to her, presented her with a digressive but convincing account of how I was of mixed parentage, specifically French-Italian with German ancestry, and that my folks were diplomats who had sent me to a local private school for the last decade. She said that I had picked up the language really well, and looked at me as if I were an exotic fruit. I asked where she was from and she said that she was from the capital, Nicosia. I insisted, 'But where are you *really* from? I mean, I can detect a mild accent, do you have Turkish heritage?' I used this line time and time again to sift out the nationalists, a strategy I'd picked up from my grandmother. However, this was the first time that my tactic was met with a different response: 'Armenian actually, and born in Lebanon. My family

and Jay's family know each other. She's a Maronite, right? They do business together, imports and exports. I've seen you both before, maybe somewhere in the north? Yes, now I remember, at Kormakitis village at Easter. But you're not a Maronite — how were you able to cross to the Turkish side?'

I felt exposed, like she already knew too much about us, and that my non-diplomat heritage would leak out of my pores. I was afraid that she would report my illegal crossing — to whom, it was not clear, but the thought was enough to intimidate me. She was at least ten years older than me, had a discreet gold cross hanging down her neck, and was in the company of some man wearing a Rolex and Rivieras, who was middle-aged and clearly heterosexual. These were all bad signs.

'What do you want?' I asked, looking straight into her eyes, our bodies unavoidably close to each other because the deck we were standing on behind the sound console was so narrow.

'What everyone wants in this place,' she said, placing her hand on mine, 'just to have a little fun.'

An ear-piercing whistle tore through the music. It was Georgia. She had decked the Rolex guy, who stumbled backwards and landed mug first on Mariza's breasts, just as she was entering the venue.

'I haven't even arrived and you all want a piece of me!' Mariza shouted, and seized the guy by the collar, his legs trying to balance as if he were her marionette.

'Throw him out, he grabbed Milena's ass!' Georgia barked. Mariza rammed him through the door and, with her foot on his butt, kicked him into the alleyway. The owner went up to Georgia and gave her an earful, as it

wasn't the first time she had started a bust-up in the bar. But Mariza had a way of sweetening everyone up.

'Get your arse behind the bar and get me and that herd of cunts in the corner a round of tequilas. Georgia's paying for them.' That was how you settled things. The owner got his money and Georgia was given a clean pass.

What with all of the tequilas arriving, it was clear that our group didn't understand what the commotion was about and, following on from the rounds on the beach, they gave a cheer 'to the greatest photographer!' I was still at the DJ deck, wondering what to do with the import-export who didn't even seem to care that she was missing her chaperone. 'Don't you want to go see if your boyfriend's alright?' I asked. She laughed out loud. It was an irritating laugh. Like someone who was rehearsing but couldn't get it quite right.

'Is that why you've been so defensive? That's my uncle. He had it coming; I'm sure he'll find something to do.' Her attitude made me uneasy. It was the way she had placed her hand on mine; a touch that betrayed both gracelessness and entitlement in one stroke.

Then Mariza whistled too, a signal that most of the regulars recognised as 'cops arriving', until she clarified with, 'Sorry, sorry, false alarm, I just wanted these bitches out of my booth.' She stood there looking squarely at the import-export and said, 'No heteros behind the DJ box.' The girl looked a little terrorised and stepped down. I tried to follow suit but Mariza body-blocked me and commanded, 'You stay right here, lesbo.' She was always unnerving. I wondered what she was really like out of this context, where she slept, how she got ready for the night, what she ate, who her friends were. She

shuffled through some CDs and put on the next track. She then turned towards me, lit a cigarette, gripped my chin with her left hand and blew smoke in my face. 'So, you're a photographer?' she asked, looking me up and down.

'Yes,' I said firmly, 'a great photographer. Haven't you heard?'

'Do you want to take photos of me?'

'I'll take photos of anyone, as long as they pay.'

'How much?'

'A half-day shoot costs £100. Three rolls of film processed and printed at a size of five by seven inches. I keep the negatives and you keep the prints. Any enlargements or copies will cost you the standard print price.'

'Do you know how many blowjobs it will take to come up with that money?'

'We can book the shoot when you're done with the blowjobs,' I shot back, trying to reflect the same brazenness.

She smiled and said, 'You better be good. Book me in for next Saturday?'

'You can take a look at the results, and if you don't like them I'll just keep them. I have another job on Saturday. Sunday is better, after 3 pm when the sun is not so harsh. We can meet here and find some interesting outdoor locations,' I said with genuine enthusiasm.

'You better not stand me up.'

'I need an advance to book you in. Fifty now and fifty after you get the prints.'

She raised her right eyebrow, gave me a crafty smile, put down her cocktail, and reached inside her Wonderbra to pull out a stash of cash. She counted out

five £10 notes, folded them, flirtatiously reached for my back pocket, slid them in, and squeezed my butt cheek. With her full lips on my ear, she threatened, 'If you don't show up, I'll come to your mum's house. You really wouldn't want that.'

'I'll be here,' I said, trying not to bat an eyelid. She took a step back to let me out of the DJ booth. Moving past her, I looked directly into her catlike eyes and said, 'By the way, if you don't show up, I'll go to your dad's house.'

Milena's husband was going to be back by the next afternoon. Jay and I had told our parents that we were having a sleepover at a classmate's, so we could stay out for as long as we wanted. We left the bar just after 5 am and teetered around the parking lot, deliberating where to go next. By that point there were over a dozen of us, and we decided that burgers at a late-night diner would fix us up. We were drunk, loud, rowdy, unladylike. Georgia's car somehow squeezed in seven of us. Milena took Sofia on her bike and they got stopped by the police for an Alcotest. Luckily, the cop on duty was her husband's cousin, so he let her go.

At the diner I told the girls about my conversation with Mariza. They seemed really excited for me, but at that hour I think they would have used any good news as a reason to go on partying. I had never taken a single photograph; I didn't own a camera, and the loser photographer hadn't given me any training and wouldn't let me take the cameras out of the shop. I made a tipsy attempt to communicate this coherently, but it was difficult to tame my thoughts or the large group. In a drunken stupor, Jay yelled, 'Bitches! Focus!' which caught their

attention for about a minute, before they broke out into an infectious round of laughter. I started to sober up as I realised that I'd devised an enterprise which I would be unlikely to pull off by the end of the week. Milena must have noticed that I was beginning to look downhearted, and I caught sight of her poking Georgia in the ribs, then whispering something in her ear. Georgia was six-foot tall, with long blonde hair and such large, strong hands that they would make a pugilist both envious and bemused. When she spoke, everyone listened.

'We need a plan,' she declared, with a grave look. 'Where can we get a camera from? Can we steal one? Can we have sex with someone? How much do they cost anyway?'

'We can steal one, of course, but it's my first shoot so I don't want to jinx it. And I really wouldn't want any of you to screw a photographer; they're all ageing, seedy creeps. I'm going to have to buy one. I already have the £50 that Mariza gave me, so I just need another £100 to get the second-hand one I saw sitting in that shop window downtown.'

'One hundred pounds! That's a lot of money! It's like thirty-five beers at the bar!' one of the girls exclaimed.

'Or a whole week's worth of wages,' said Milena, frowning at the beer comment.

'I can ask my boss to give me an advance for this week. Maybe I can ask him for £50 and you can give it back to me when Mariza gives you the rest of the cash. We still need another fifty,' Georgia said.

'£50 is nothing. We can totally pull it off,' I said, with more confidence than I actually possessed, and proceeded to hatch various money-making plans.

The next day, Jay stole a tenner from her dad's stash in the wardrobe. Georgia and Milena nicked some spirits from a supermarket, and resold them for £20 to a friend who ran a small bar that played rock music. That Monday I sold my really worn Dr. Martens to a classmate for a tenner. By Tuesday I only had to come up with ten more pounds. I sifted through my mother's drawers and scraped together £1.20. On Wednesday I visited my aunty and she gave me some change 'for ice cream'. On Thursday, in the late afternoon, we turned up at the shop with £146.40.

'Hello! We want that camera! The second-hand one by the window. How much is it?'

'It's your lucky day! The sale started today so we've reduced it to £100. It's in perfect condition. Not a scratch.' My face lit up and a tear glistened in the corner of my eye, like one of those anime characters.

'Dammit! We only have £96.40, sir. Would you please accept that amount? Please, we were really hoping to start our school project today,' Jay petitioned, while I was still gaping at the man's moustache. The moustache grinned and walked over to unlock the vitrine. I couldn't believe our luck. We bounced out of the shop squealing with joy and, once around the corner, Jay pulled out two brand new film cartridges from somewhere in the jumper she had wrapped around her waist.

'When the hell did this happen?' I said, beaming from ear to ear.

'When you were busy looking like a six-year-old in front of an ice cream van.'

We met up with the girls later that day, and I gave Georgia back the £50 advance. So far so good. Now the

problem was learning how to take photos by Sunday. The next day we had school, and I would miss most of the sunlight if I stayed till the end of classes. I took the camera home, managed to load the film, and packed it along with the extra cartridges. Jay was going to help me bunk off so that I could cycle down to the seafront and do a test shoot. When the bell rang announcing the end of the lunch break, everyone started making their way back to the classrooms like tranquilised cows, while we headed for the locked gates like a pair of foxes. The walls around the schoolyard were over two metres high, but we found a way to work around that. Jay would lock her fingers together in a cup shape, and I would place my foot in her hands while holding onto her shoulders. On the count of three she would heave her stirrup-like palms upward, while I jumped to reach the top of the wall, as though I were mounting a really tall horse. She then hauled over my backpack, and tossed me a pack of Marlboros with a fiver rolled up inside the packet. Imitating her mother's voice, she whined, 'Get yourself something to eat. You always forget to eat. Look at you! Skin and bones!'

I made it to the forest-like part of the beach where the eucalyptus and acacia trees could provide enough shade to conduct my first self-taught photography class. My palms were sweating but it wasn't from the heat. It was from wanting to create something perfect, exactly as I was experiencing it before me. To be able to capture so much more than I could see: the awe, emotion and wonder that accompanied the experience. What is it that photographers do to produce in the viewer a blistering heartache? How does an accidental moment become an

eternal imprint in the minds of so many people? How do you capture those moments where time is wrecked, elongated, paused, contorted, wielded into a thousand stories? And what about the necessary self-obliteration that gives way to being completely present in the encounter with a photo; was that something that I could actually bring about? I didn't know how to capture my unsettled state in that specific landscape. I didn't know, yet I desperately wanted to convey to someone this moment that they had never lived, but that could liven every boundary of their flesh with scintillating and terrifying familiarity.

My eye was drawn to a spot on a particular tree trunk where a large branch had been sawn off, exposing the tree's rings of growth. I framed these rings in my viewfinder, circles within a rectangle, and I remembered those wooden toys consisting of geometric shapes which toddlers would try to fit into the correct hole. With a step to the left, the rings would take on a new perspective. With a step back and a refocus, I could see the background blurring, changing the way the tree was making me feel, regenerating itself before me, prompting new ideas and sensations. Simply looking at the tree with my own eyes, in all its panoramic existence, against the backdrop of the sea with a cargo ship in the distance, amongst so many other trees sprouting out of a mixture of sand and earth, the feeling of an overwhelming completeness flooding my senses — that experience was something that I could not encapsulate with the camera. But I hoped that I would be able to capture something of that feeling, the little dance of tiptoeing around the tree until something, some part of it, demanded to be seen in precisely that way.

I fiddled around with the camera settings in a hit-and-miss way, hoping that some of those combinations of aperture and shutter speed would produce sharp and evenly balanced photos. After shooting half a dozen frames, I felt a sense of despair and excitement at the same time. I had no idea what I was doing, but I felt free doing it. Rarely has an activity ever felt so right to me. Holding the camera in my palms, I looked at it as if it were the source of all my anguish, and I might even have been talking to myself when I heard a woman's voice say, 'Hallo! Das is good camera.'

She was wearing hiking shoes (only tourists wore those), cargo shorts and a fisherman's hat. Her grey, frizzy hair escaped from behind her ears and coiled around her purple half-rimmed glasses. She had gentle eyes and a geeky, jolly smile. She was carrying a backpack, and I realised there was a strap across her chest, which was attached to a camera hanging at her hip. 'I just bought it yesterday, but I have no clue how to use it,' I replied cheerily, almost relieved to have been interrupted.

She let out a chortle and said, 'Leben wie gott in Frankreich.' Amused by the quizzical look on my face, she translated: 'In Germany we use the phrase, "Living like god in France" when we want to say that someone is living the good life.'

To my fifteen-year-old self, there was something unfamiliar about her, and I struggled to understand what it was. I just didn't know in what way — what was the correct way — to relate to her. She started to talk to me about the importance of framing, before getting down to the nitty gritty technical stuff where, drawing a triangle in the sand, she presented me with the holy triad of

photography: ISO, aperture, shutter speed. She instructed me to log every frame I took with these details. We started by keeping the speed the same while recording increases in aperture. We then kept the aperture fixed and changed the speed setting. We shot the rest of the film together; thirty-six frames that constituted my first real class in photography. I removed the film and put a new one in. She seemed pleased with me and said, 'Copy this triangle into your notebook. If you understand this, everything else will be easy. I go to take some photographs too now.'

What I felt with Greta was an unprecedented encounter with kindness. Kindness from a stranger, a kindness that wasn't for some ulterior motive, such kindness that it overwhelmed me and the overwhelm turned to sadness. Why had it taken me so long to come across someone who just gave freely, without expecting something in return? My family, my teachers at school, the grocers and the coffee shop owners, the strangers we met at bars and clubs: there was not a grain of this kindness in anyone I had met so far. From a very young age, I had observed how people seemed to have some sort of transactional value associated with them, either explicitly or implicitly. This was made clear by the shopkeepers, the landlords, the handymen, pretty much everyone; but especially the men who, at some instance or another, wanted to have sex with my mother; rather, to take sex from her. I knew this from the way they looked at her, and there were enough times they tried to touch her inappropriately, even in my presence. It took me years to understand why my mother always insisted that I should be at home when men came round. At the

time I thought that she was just dumping another chore on me, or that she supposed I understood something about broken washing machines that she didn't. Those men rarely had anything to offer in return, since they were all married, but their fantasies persisted, and so they would let her pay in instalments, or would put a little something extra in her shopping basket, hoping that one day, if the circumstances were right, if they were to bump into her in another context, perhaps then she would materialise some aspect of their delusions, that she would agree to make even a fraction of their wishes a reality. Some of their wives were also kind to my mother, and especially to me, but I soon realised that this was a way for them to enact goodness, and their superiority in relation to what they otherwise thought was an unfortunate and pitiful situation. A divorced woman was pitiful, no matter the reasons for the divorce. If she also had children it was worse, and if you added in that she was poor and a foreigner, she was as wretched as one could be.

To me, my mother was a graceful, educated, charming, creative polyglot and artist. To the local married women, she was a beautiful, and hence irresistible, Eastern European blonde (this visible identity had a single incontestable connotation and function). A blonde who worked as a cleaner by day, and as a waitress in a sleazy bar by night. So, not only was she pitiful, in their eyes she was also a veritable threat. The fact that she was raising the child of a Cypriot man — not a very respectable man for that matter, but still a man — made her a little less foreign by proxy. They spoke to her in dialect and she responded in dialect, albeit with an accent, and

almost every sentence they uttered ended with *ekatalaves*? (*Do you understand*?) 'These eggs are from Mrs. Nitsa from Kolossi, who brings them fresh to us every morning, *ekatalaves*?' In turn, my mother's every other response had to end with a reassuring *ekatalava*; *I understand*, she would conclude. Even when the plumber fixed the washing machine and she asked how much she owed him, he placed his hand on her waist and said, 'we can sort it out between us, *ekatalaves*?' And, at those times when she would refuse to say *ekatalava*, whatever it was that we needed would become harder to source. *I understand*, she would reply numerous times throughout the day, in a context and culture where very little could really be understood.

I thought of all the women in my life; I thought of Jay, our closest friends, also my mother and Aunty. What I received from them was a type of love that was inexhaustible, an almost senseless devotion, a loyalty so exaggerated it smothered you, enveloped you in a bond from which you could not, would not even if you could, escape. This was the love and generosity that we knew, and the only one we were able to give and receive, but I don't think any of us knew how to be kind.

Greta must have noticed the stratus of thought that clouded my forehead: 'Come on now, you are very good, a few more days like this and you will take great photographs.'

I was sad that she was leaving. Just like that. Not knowing how much this meeting would change the course of my life, to this very day. And as sadness was one amongst many feelings that I didn't know how to express, I collected myself and said a little formally, 'Greta, I

cannot thank you enough. Maybe I can write down your address in Germany and send you one of those great photographs that I will take one day.'

She laughed, the fullest and shortest *ha-ha* I have ever heard. 'I live in Paphos. I bought a villa there last summer after I retired. So maybe I will see you or your photographs again.' She winked at me and tapped me on the back in a matter-of-fact but affectionate way.

As she walked away from me, I called out to her, to make a point about the villa: 'Greta, one last thing, *Leben wie gott in Cyprus.*'

She shook a digit at me and exclaimed, 'You see, you are a good student.' I heard her chuckling while treading through the sand, with her head held high like a traveller predestined to good fortune.

I never did see Greta again. I probably wouldn't recognise her now even if I did, but that encounter has taught me to recognise kindness even when it takes the most unlikely of forms. One of my closest friends was raised in the godless land of Estonia, but our paths crossed in London. I was desperately looking for cheap accommodation and ended up in a dingy box-room, in a five-bedroom flatshare with no living room. I would leave my door open because the room was so small it was claustrophobic. A couple of days after I moved in, she saw me hunched over a pile of books on my tiny desk, doing an all-nighter for an overdue essay after having completed a twelve-hour waitressing shift. She was wearing sports gear and a sweatband and, with her hands on her waist, she said, 'So much work is not good for you. Come with me for a jog. It will clear your mind.' She had that something Greta had. She also

appeared in my life at a time that ticks with seconds which you feel may tip you over a point of no return; nonetheless, you remain suspended, balancing on the edge of despair. It is during such moments, when you feel pushed into a corner, with no reasonable solution in sight, that there is a tear, a crack in everyday reality, and out of these cracks something or someone appears. Appears is the wrong word; it is as if they are conjured by the unmitigated force of your existential crisis. I remind myself, to remind myself, that these cracks will always manifest when I cannot manifest the future.

Saturday morning, I arrived at the shop at 10:05 and, this time, he was already there. He seemed moody. He commanded me to sweep and mop the floor. I couldn't gauge what his attitude was about. I quietly started sweeping from the front of the shop to the back. I then mopped. He didn't say a word. He just looked out of the window, occasionally jotting down some numbers and names on a piece of paper. When I had finished, I asked him what I should do next. I was keen to process my films to see if they were any good, so I asked, 'Do you have any orders? Maybe you could show me how to process film and print it?' I wasn't sure if he had heard me, because he continued to look at the piece of paper in front of him. 'Or maybe you can show me how to develop the films I shot yesterday?' I asked coyly.

This caught his attention and he said, 'Give me the black and white first. The colour is easy so we can do that next.' He showed me how to pop the film out of its

canister with a bottle opener. This had to be done in a dark bag so as not to expose the negative to light; then you had to fumble around trying to reel the film onto a spool, and finally place it into a lightproof processing tank. That seemed straightforward, even though it took a considerable amount of time. In the tiny kitchen, he mixed up some chemicals and I wrote down the instructions. He didn't say much, and expected me to somehow learn just from watching. I could smell his breath. He hadn't had breakfast, probably not even water, as I could see his cracked lips under his overgrown moustache. It must have tickled as he repeatedly ran his fingers over it, in a slightly disgruntled gesture. I had no choice but to observe him closely in the tight space that we occupied.

Within half an hour the film was ready, and he clipped it onto a contraption that looked like a miniature laundry airer suspended from the toilet ceiling. 'Give me the colour,' he ordered. We moved to the middle of the shop by the C41 film processor, the studio now reeking of the acetic acid that we had just used. He operated a small, flat device to retrieve the colour film from the canister, but I didn't understand quite how it worked. He said that I could practise later with the films from the pending orders, and pulled two out of an envelope, passed one to me, and started to demonstrate again. He took my hand, the one that was holding the film, and pushed it towards my ear. 'Here. Hold it here so that you can hear the noise it makes when it's ready for you to pull it out.' It was the first time he had touched me. His fingers were fat, nails unevenly trimmed, his palm moist, squeezing my wrist. With the film-extracting device inside the canister, I wound the

spool until I heard the tiniest snap. At that moment he let go of my wrist. That snap was like the noise that Svetlana's nails made when she was thinking about something in silence. She would flick the nail of her middle finger against the nail of her thumb, often staring into the void, while she smoked. How does he know my mother's friend Svetlana? I thought to myself.

I snipped the negative tongue that stuck out of the canister and sellotaped its edge onto a clear plastic card, which was to be inserted into the processing machine. 'Not yet,' he said sharply. 'You have to wait until the light stops flashing and the machine makes a beep. Then it's ready for the next film.' I asked if we could print the black and white film in the meantime. 'Go check if it's dry. If it's not, use the hair dryer in there.' He always spoke like this. Not exactly directly, but aggressively, and if there was any trace of emotion, it almost always sounded like mild frustration. I brought the film out and took it to him. He lifted it up to the lamp, examined it, then sat on the minilab stool and gestured with his fingers for me to come closer. 'Look here. We have to make adjustments before we print it.' I tried to inspect the negative on the monitor but this seemed spatially impossible with his thigh in the way. I found myself making awkward attempts to look at the image without touching his leg but he didn't seem to care and made no effort to give me even an inch of space. 'Can you see it? This one is too dark, so we have to brighten it.'

I was annoyed but I didn't know what to say, so I asked, 'Can you just print the whole roll as it is? I want to see the different light exposures so that I can under-stand what I did wrong.'

He made a strange grimace. 'We don't waste paper on tests. If you want to see the negatives you can just look here. You press the key with the arrow and it moves to the next frame.' He just sat there on the stool, his body turned to the side of the minilab, my film hanging from the printing gate. It was as if he were deliberately agitating me, yet I failed to comprehend what he was expecting or asking me to do.

I remembered a wicked trick that my beloved eldest cousin Michael would play on me. He routinely looked after me when Mum had to go to her evening shift, and we spent our time watching movies, talking and laughing a lot. He seemed so tall to my eight-year-old eyes, and the fact that he was eighteen, had left school, and didn't go into the army like they all did, made him particularly handsome and different from the rest of the boys around me. It was years later that he came out to me as gay, and that information offered an added layer of explanation as to why I was so attracted to him. Even when he would torture me by holding a chocolate above my head and say, 'This very special chocolate is like nothing you have tasted before, and it's all for you if you can catch it!' I would then reach out to take it from his hand and he would fling his arm back like a fishing rod and then bring it back down to dangle the chocolate above me. Jump after jump, I tried to snatch the chocolate out of his hand like some playfully obsessed kitten, and all the while he laughed more vigorously at my every failed attempt. I was now replaying the same game, but with someone whom I not only did not adore, but who made me uneasy at best, and at worst filled me with disgust. I scanned his face for some evidence of wickedness, but

he was simply looking outside, almost as though he were resting or thinking of nothing, just sucking his bottom lip a couple of times, moisturising the cracks.

The gap between his knee and the printer was about a foot, and I was trying to assess how exactly he was inviting me to occupy that tight space. I focused on the arrows on the small keypad and tapped the one I could reach the easiest, without having to squeeze between him and the machine. 'That's the fourth frame now. Go back to the start to see all of them,' he said without looking at the viewfinder. I tried to peek at the image on the display, pressed the other arrow and then I felt his hand on my shoulder. I froze. 'You can't see from there. What are you doing? Look into the machine!' His hand still on my shoulder, he wedged me between his legs and leaned forward to point at the tree that I had shot the day before, and that was now on the screen. He started to instruct me in a tone I had never heard him use before. It was gentle, pleasant, cooperative, almost selfless. I felt his belly against the belt of my jeans, while he explained colour management in clear and concise detail, demonstrating the changes in brightness and contrast by pressing various buttons on the panel. I don't remember anything he said, apart from the closing sentences to that exceptional lesson: 'You see, people don't want to receive their photographs exactly as they shot them, because they are always bad, so you have to give them what they want,' — here he pressed closer to me, and I felt his bulge against my ass — 'a version that has nothing to do with reality.' His fingers still pressing the buttons and adjusting the images to their finest versions, particles from his hot, faeces-reeking

breath on the back of my neck, combined with the pickled atmosphere, made my stomach turn. I think I might have stopped inhaling, and I leaned forward to the point where the edge of the viewfinder was digging into my breasts. 'Of course, this means that they will never understand what they did wrong, but it does encourage them to carry on taking more photographs. Our work here is always about bad photographs, never good ones. *You'll get used to it.*' He casually moved back, got off the chair, and went over to the shop counter. 'I'll leave you with this order here and you can try to print it as best as you can. I'll check it when I'm back in on Monday.' While he spoke, with his back to me, I noticed his hand reaching into his trouser pocket, making a slight motion which, if it were a sentence, would be a maxim for male dominance. 'Take two more films today to practise. I'm going to the shoot. See you next week.' He picked up a bag with some equipment in it and left through the back door. It was only twelve o'clock.

I don't remember much else from that day, but I am certain that I did print those images, because Jay found them a decade later in a box in her parents' shed. I do recall making phone calls from the shop's landline. I tried to reach Jay but she wasn't home, so I called the cafe and her sister said that she'd gone off with some guy on a red Vespa. I told her I would pop in after work and asked her, if she saw Jay or any of the girls, to tell them to meet me there. I also remember taking twelve rolls of film that day. It felt like a fair thing to do. I'd earned it, I deserved it, he deserved it: it was the right thing to do, a cosmic balance.

The cafe was busy. Tina made me her classic halloumi and roast beef sandwich. I couldn't eat. She brought me a beer. I asked for a whisky too. She noticed that something was wrong but she didn't really have time to chat, so I told her that I would tell her later. Milena and Georgia showed up, but they weren't in a good mood either. I told them what had happened. They barely said a word, and I noticed Georgia clenching her fist every time she took a sip of beer.

'I don't know what to do. He hasn't paid me anything yet and I haven't even started the job. Tomorrow I'm shooting Mariza and I will have to print photos for her. I can't afford to go to the local shop to get everything done.'

They remained silent. Milena then removed her large sunglasses. She had a bruised eye. She started to swear in Serbian, and then in English: '*Nek ide u kurac!* (*He can go fuck himself!*) Fuck him! Fuck him so hard that he will not forget you. Go there again until you get what you need and then never go back. You will never see any money from him. Take whatever you find and print more than you need. He can't do anything and he won't do anything because he knows that what he is doing is fucked up. Next Saturday we will send one of the girls every couple of hours, just in case he tries something too extreme. They can pretend to be customers, maybe leave a blank film for processing which we will never pick up.'

Milena spoke with such conviction, I was sure that this was the one and only solution to my dilemma. There was no disparity between her oratorical force and her lithe figure. Neither did the purple oozing eye deflect from

her power, even though she was clearly frail. She seemed to me a warrior, a fighter recovering from battle, tending to her injuries while getting ready to go back into the ring. I asked what had happened. She said that her husband had bumped into his cousin, the cop who stopped her for an Alcotest the night we went out, and he had told him that we were all drunk in the early hours of the morning.

'Has he done this to you before?' I had tears in my eyes when I asked because, despite her admirably stoic composure, I knew that he could kill her, accidentally or intentionally, as if she were just a body, a body without consequence, without ancestry or lineage. A body whose annihilation would not have anyone mourn for her, in a country where she is just a foreigner.

'A couple of slaps and some shoving every now and then. But this time he was out of control.' She lifted her blouse and showed me more bruises on her back and sides.

'Milena, you should go to the police.'

She laughed sarcastically and the movement made her wince. 'The police. Really? He *is* the police. His cousin works there, his uncle is some kind of chief in the Criminal Investigation Department, and he is taking exams now to work for them. He will get the job even if he doesn't pass.'

'It's not possible. They can't just let this happen. What if you speak to them and ask their advice about what to do?' I said, exasperated, and once again that feeling of hopelessness slowly turned to anger.

'Really? Is that what your mother did? How many times did she go to the police? How many times did

she go to social services, to lawyers, to the church even! Nothing changes. And I still have two years before I get my visa. *Ekatalaves*?'

'I'm going to slit his throat,' Georgia grumbled.

'Oh shut up, Georgia. I don't need any more macho attitude. You can show off like that to those teenagers you hang around with, but not to me,' Milena stormed, and then took a swig from my whisky. Tina came over with a tray of beers and some shots. She saw Milena's face, put the tray down on the table and looked around.

'Keep your voices down. Her husband's friends are sitting two tables behind you.' Then she feigned laughter and said more loudly, 'Cheers, girls! So nice to see you!' She collected the shot glasses and cleared our ashtray and, leaving us, whispered, 'I finish early tonight but my boyfriend is working till late. Meet me at the gay bar at midnight. I'll tell him to pick me up from there when he finishes his shift.'

I stopped off at home to shower and have a rest. Mum had a night off for a change. Svetlana was over doing Mum's hair, and they were having a few drinks before getting ready to go out for some fun together. They greeted me with the usual warmth and elation. It made me happy to see them like this, carefree and cackling at their own inside jokes in a fusion of Russian, Ukrainian, Cypriot and English that I couldn't always understand. I didn't want to tell them about my worries and put a dampener on their mood. Svetlana had a series of pet names she would call me in Ukrainian. '*Koshenya* (*kitten*), have a beer with us and let me do your hair.'

'How do you know the photographer?' I asked her directly.

They looked at each other and my mother said in dialect, 'You haven't even started working and you're already complaining?'

'I'm just asking a question,' I retorted.

'*Moya lyubov* (*my love*), how do people know each other? From work, I met him at work,' she said sweetly.

'Are you still working at that bar? Isn't he married?'

'All men are married on this island! But one day someone who is not married will come to the bar and I will snitch him from everyone,' she joked and, while my mother joined in the banter, I remained cold. Struggling to participate in their conviviality, I excused myself and slipped into the shower.

The jet of water on my head was like a palliative: it soothed me, it slowly undid the knots in my stomach. The more it ran down, from face to toes, the more my body let go of the tension, as if my armour were coming undone, dissolving and disappearing down the drain. I started to cry. It was a couple of tears at first, and they seemed so involuntary that I wasn't sure if I was actually crying. I thought that I was probably just physically tired. I didn't cry because of the photographer; something like that could no longer make me sad, only angry, hot with fury, incensed by the injustice, potent with vengeance. Nor was I crying about Milena's painful predicament. That too made me angry, and, as familiar as I already was then with the atrocities of mankind, it took many more years for the sadness that I carried to supersede my zealous rage. When it did, it almost crushed the life out of me. But in that moment, with

the water washing over me, I cried because I saw little cockroach tentacles peeking out of the broken bidet's drain. I cried because the bathroom tiles were cracked, some of them missing, and the paint on the ceiling was peeling. Because the cold water tap had been temperamental for months and we were approaching the summer, yet another fun-filled summer with no aim and no future. I cried because my plush pink towel with its bleach stains was an item rescued from the local hairdresser's trash, now hanging on a rusty nail. I looked at the flip-flops that I'd had for years, a size too small for me and with rents in the soles. I sobbed with a desperation that, until then, seemed unknown to me, as I picked up the two-litre shampoo bottle that still had the price sticker on it, which read '£0.69'. I tried to steady myself, washed my face under the shower head, and fixed my gaze on the French magazine, *PHOTO*, which I had stolen from my favourite bookstore. I was almost certain that Mary the shop assistant knew I was stealing them, but she let me anyway. This thought made me cry too. The magazine rested on the left-hand side of the windowsill, where Mum had accidentally broken the glass trying to prise open the jammed window with a screwdriver. There was a small canvas of some Orthodox saint that my mother had been commissioned to paint, but the client never showed up, and this icon, still on its tiny stretcher bars, was propped against the hole to keep out the cold. This also made me cry, because Mum had stopped painting anything for herself since we escaped from her husband. I cried because I didn't know what I had to do, at that age, to make things better, to fix things, to change whatever direction our lives were taking.

I cried because there were no signs around me that could make me believe, could give me a trace of hope, that this was not it. This was not all there was. If this was it, I would rather die. I cried because the dreamlike lives of the photographers in that magazine, or the fantastic images that they took, just didn't exist, would never exist, on this island, in this lifetime, in my lifetime. I cried for me and for those before me. I was inconsolable. I hadn't cried in years, and I wouldn't cry again for many years to come. I didn't know that then.

Mum knocked on the bathroom door and announced, 'Jay's on the phone and she's looking for you!' I sprang out of the shower, dripping everywhere while trying to wrap the towel around me, and dashed to the receiver. I heard my mother joke to a baffled Svetlana, 'It's Jay. These girls will never find boyfriends, they are so in love with each other.'

'Jay, come over. Everything is fucked up,' I said urgently.

'I can't. He locked me inside his bedroom and left but the idiot probably forgot that he has a landline in here. He was pissed about the motorbike and he also saw me making out with Georgia. His parents are away for the weekend and I don't know when he will be back or where he even went.'

'What about the window?'

'Second floor. It's too high to jump. Bring a rope. My dad has a good one in the cargo bed of his pickup truck, so go by the house and just take it from the back. Don't let him see you. I'm next door to that posh house with the avocado tree on the way to school. The bedroom is at the back, next to the garage. Hurry.'

I cycled faster than I thought was possible, but it still took me almost an hour to get to Jay's and then to the guy's house. I dumped my bicycle at the entrance of a building round the corner and ran there. I noticed that the canopy of their garage had a camera. I sneaked in through the side and activated some sensors that flooded the area with light. I climbed up the pole of the canopy and snipped the wires of the camera with the penknife that Jay had given me when she decided last year that we should go hitch-hiking across the island. I quietly called out Jay's name and she appeared at the rear window, gesturing to me to fling her the rope. She made a loop and passed it around the leg of the bed frame. The whole operation only took a couple of minutes, and then we ran to pick up the bicycle. Jay sat on the saddle and held onto my waist, while I pedalled us to my house. For the whole journey we said nothing to each other. It was only much later, when we got to the bar, that we started to find the words; that we started to discuss all that had happened in that one day.

I sat between Jay's legs, and she spent most of the night hugging and squeezing me. Milena and Georgia did the same. Tina joined us after midnight and started drinking neat vodka while dancing with strangers. Too exhausted to talk anymore, we also danced. We got so drunk that night. I vomited in the bar's toilet and then carried on drinking. Tina made out with Pambos, who took her t-shirt off and removed his own shirt, and then they just went on grinding against each other until her boyfriend came to collect his topless, drunk girlfriend. Georgia was fairly quiet, then, towards the end of the night, sang along to a couple of melodramatic Greek songs

before she blacked out. In between having serious conversations with Andreas, a gay retired mathematician who was like a father figure to her, Milena entertained herself with our debauchery. She later drove Georgia's jeep home and put her to bed before returning to her husband. Jay and I walked home, arm in arm, too drunk to care about all the catcalling. For some reason, everything around us looked so funny: the kitsch decor of the local bars, the men's dull faces, the women in heels walking like ducks, and their clutched purses, the way they spoke, the way they moved, and the strange disapproving looks they gave us. Every single thing about them was hilarious. We ate a *souvlaki* (*pork kebab*) on the way, which Jay threw up into my bathroom sink, because I was sitting on the toilet taking a piss. Luckily my mother hadn't returned home yet to witness our state. Jay's gagging made me giggle and that, in turn, made her burst into laughter and vomit at the same time. Somehow, I felt so much better about my earlier moment in the shower. It was as if all this puking acted as a cleansing ritual. We shared a 7up and went to sleep spooning each other.

We woke up just after midday. My head pounding and my acid-filled stomach making strange noises as if a war were taking place inside me. We ate an entire loaf of bread with Russian salad, *tzatziki* (*yoghurt dip*), gherkins and various leftovers from the fridge. Everything tasted like garlic. I drank two pints of water, another 7up, and, around 2.30 pm, I made a *frappe* (*iced coffee*) and tried to pull myself together for the shoot. The first cigarette

I tried to smoke almost made me vomit again, and I couldn't even drink the coffee. I decided that I would get a fizzy drink from the kiosk and wait for Mariza outdoors.

It's difficult to describe exactly what happened the afternoon of the shoot. I was certainly anxious, but I kept a cool head, and asked Mariza to model as though I knew what I was doing. She was at times shy, but generally bold, posing in a way that gave me an indication of what she wanted from our session. We were like two strangers trying to build something together, without really knowing what tools the other had. Mariza wanted to look good and I wanted to make Mariza look good, but we may have had different ideas of what that meant. She wore a fishnet maxi dress, and had over-tousled her hair to the point where she looked like a lioness tangled in a mesh. She started to perform a version of femininity that seemed to be taken directly from an outdated manual found in the back pocket of a punter, or the presenter of a cheap morning TV show. Rather than femininity, this was more like the performance of sexual availability and, with her every move, you could almost hear the instructions: 'Hot, sexy, pout, fuckable, I've done it all, I want it all from you, big boy, come and get it you stud, give it to me daddy.' What I saw from Mariza was a rendition which seemed to cater to the predefined aggregate of male desire, a desire so very often defined by lack, possession, domination. Why on earth would anyone want to adhere to that? In the absence of any alternative, being something else was not really an option, especially if you were sexually attracted to men.

I hadn't known what femininity could mean to me, because the first signs that my body displayed of this

register were the very signs that attracted a series of unforgivable acts. It is such a shame that, as you start discovering your sexuality (regardless of orientation), in next to no time you realise that sexuality is determined for you by your gender, since gender is the rule, and sexuality — or, dare I say, pleasure — the exception. Gender stifles the new and exciting developments which ignite a person's sexual curiosity towards another being, along with the urge to explore their own body, a body yearning to be wrapped in a blanket of sensuality. While sexuality could lead into a boundless universe of sensations and experiences, it all too quickly becomes confined to very specific acts and desires.

And it is precisely that aspect of me — what one might commonly but incorrectly refer to as 'femininity' — that I had been robbed of. It was stolen bit by bit, starting from that day when a Cypriot taxi driver slowed down by the pavement on the seafront, and rolled down his window to call out to me in Russian a sequence of words, meaning one and only one thing: '*Priviet! Harasho? Zahadi… Davay.*' (*Hello! Ok? Come in... come on.*) I was ten years old. It was taken from me as I was playing darts one night, waiting for my cousin Michael to pick me up from my mother's night shift, when I overheard Svetlana tell her, 'You might not have noticed, but all the clients have. She needs a bra and I don't think you should bring her here again.' I was eleven.

At that young age I realised that the budding morphological signs of my gender, coded as feminine, were simultaneously the signs that guaranteed I was available for male use. Then we had that distant relative or family friend whose name I can no longer remember,

but who, one summer, was made the guardian of all of us neighbourhood kids. He was in his mid-twenties, tall, handsome, curly long hair and a perfectly trimmed beard, working with one of my uncles, probably in construction. He would take us all to the bowling alley or to the beach and, on some nights, babysit us collectively so that our parents could go out, or, in my case, go to work. My mother entrusted me to this guy who I immediately took a liking to, as he was so much fun and always made me feel special. He would tell me that I was smart, commended me when I played fairly, and tickled me, telling me that he did so because he loved the way I laughed. One night he came round to our house to watch over me while Mum went to work. It was the first time that we were alone. We put on an action movie, ate some fast food, and then I went to bed early as it was a school night. I woke up just after midnight with his hand on my breast and his dick rubbing against my ass. I laid there, frozen, with my heart pounding in my eyes until he finished doing what he was doing. I was twelve. The next day I just went to school in the morning, and it would be two days before I saw my mother, as her work shifts rarely coincided with me being at home. I told her what had happened. I don't remember what I said exactly, but I remember sobbing. She became angry and I felt that she was angry at me. She didn't talk to me about it. The only thing I know is that I never saw this young man after that day, and my mother never kissed me on the lips again.

So many occasions of this theft, like that day when a dozen boys leapt out of the bushes, and one of them prodded his arm up my skirt and managed to stick his

finger inside me, while another boy grabbed Jay's tits. That was the last time I wore a skirt until I left the country a few years later. We were only thirteen. There are so many more incidents to recount but they all just fade into each other after the first few. That decade of our lives was like a never-ending battle on the streets, in the home, with the family (the "dirty uncle" joke was not a joke; it was our everyday reality, in which both Eleni and I were continually removing our uncle's hand from our lap when we sat down for lunch, and he would casually squeeze our thighs in full sight of the family, saying, 'What beautiful girls you have become'), at the beach, during any sports we took up, at any job, in any public space, even private space — you knew what you would get and you never let your guard down. By the time we sat exams to study abroad, we were mentally and physically debilitated. Not only had they stolen whatever relationship we could have had to femininity, on a much more profound level, they had raided our integrity.

If my femininity — one that was read back to me, and not one that I could myself perceive in/on my body — was what men wanted to possess, then surely I would have to rid myself of this curse if I were to be free from their assault. As a result, the link between femininity and sexuality became unhinged, and femininity started to exist on a parallel line alongside sexuality, a line that never really converged with either the practice of sex or with my sexual desire. In this impasse, where femininity is no longer mapped onto biological sex or the expression of sexual identity, it becomes a mind-boggling phenomenon.

Maybe the only haven we had then was the ordeal of a school that we all hated. Yet it often went to great

lengths to protect us girls from that species called man. The strange Cypriot men who loitered outside the gates, ogling us; on a couple of occasions, they were caught masturbating by the Franciscan nuns, who would then curse in Italian and throw bread at them. Yes, on this island, even nuns will curse. The boyfriends who picked up the senior girls were always given the evil eye; some were even reported to the girls' parents and, as frustrating as that was for us then, there was something that the nuns knew about men that wasn't just shaped by their religious chastity. They knew the darkness of it all. They knew from the Filipina mothers who sent their illegitimate daughters to our school, because no public school would enrol fatherless kids, that their children were sometimes the outcome of rape. They also knew from Eastern European women, like my mother and her friends, the difficult journey they took in search of a better life, a life which inexorably culminated in becoming some man's property through marriage and reproduction. Because, even though they birthed Cypriot children, according to the law they remained foreign women, tied to their loveless marriages for years. All those daughters were safe here too, and they received an education that could, in theory, get them away from the island. Yes, that was probably the best place we could be, especially us foreign-looking girls who didn't seem to belong anywhere else. We tried. We tried so hard to fit in everywhere. We spoke better dialect than any of our olive-skinned peers, who were trying to make their way up the social ranks. While they desperately tried to climb up the ladder of the family business that they came from, or had married into, we

were struggling to see any viable path for our future, let alone our careers. We had to speak rough because most of us didn't have fathers to talk for us. We had to deal with the world of men, and those men only responded to the things they wanted to hear.

'Where did you go to school, Mariza?' I asked her casually, while loading the next roll of film. Mariza always spoke proper Greek, and her command of American was perfect.

'Is this a photo shoot or an interrogation?' she scoffed.

'It's just chit-chat,' I said indifferently.

'That's what they all say darling, then they try to find out who my classmates were, whether I was a crap student, who my family is and so on and so on.'

'Were you a crap student?'

'Not at all.'

'So what happened?'

'Everyone thinks that something tragic happened. None of that bullshit and misery that you all gossip about. I went to a private school here, then to New York, got myself a business degree and had a great time spending daddy's money. I was supposed to come back and run one of his many businesses, but there was no way I could do that and look like this. So we made a deal. I disappeared for almost a decade, and now when I visit I am unrecognisable. He gives me a monthly stipend and occasionally I'll do something for him behind the scenes. But otherwise, most people from my previous life have no idea what happened, they just think I've been in the States since then.'

'And what do you do in New York?'

'Oh I moved to London when I graduated. I'm mainly between London and this shithole now.'

'Why do you come back if it's such a shithole?'

'Three things. The food, the weather, and the men of course! Have you not seen what British men look like?'

'You hate Cypriot men, Mariza. It's so obvious even they can tell!' I said, sneering a little but intending no harsh criticism. My comment made her flinch as if I had revealed a big secret of hers. Her eyes pierced mine and, in that very instant, a small motorbike turned into the alley with tyres that were almost caving in under the weight of its driver. A middle-aged man in sandals, white vest and swimming trunks slowed down to check us out and then he flicked his tongue at Mariza. She ran up to him and managed to kick the back of his bike, and, as he sped up to escape her wrath, she swore at him in such vulgar dialect I was flabbergasted by her transformation. She damned his receding hairline (*kelli*), his fatness (*shiska*), his gypsy clothes (*gifte*), his limp dick (*pampakoville*), his ugly-as-a-demon-in-a-cave face (*stishon tou lakkou*), his retarded dick (*kathisterimeni villa*) which would only bear donkey spawn (*gaourospora kopellouthkia*), and concluded the sentence with a pyromaniac curse on him, his house and his entire family (*ishalla na krousis esi je oullon to spitin sou*). The nineties were glorious for many reasons, but (the lack of) political correctness was not one of them.

I was laughing uncontrollably and, even though the drinks from last night were making me a little nauseous, I still couldn't stop. Mariza saw me bent over in fits and she burst out laughing too. We decided to take a cigarette break, and I drank another 7up while we sat on the

crumbling walls encircling the nearby hammam. I felt closer to her than I ever had, and I think she felt the same. We were sitting next to each other, elbows hunched over our thighs and our legs spread open like men. Noticing this we both chuckled, and then I asked her, 'So have you ever been in love with a Cypriot man? Is that why you keep coming back?'

She smirked, and in a very theatrical way responded, 'Darling, people like me are not capable of love. We have other talents.' I knew exactly what she meant. Love was definitely not one of our talents. We were hardened. At the core of us there was no heart, but a ball of steel, a heart hardened into a state of self-preservation.

'Deep down I'm a lesbo like you. I just like cock. If lesbians had real cocks my life would be perfect,' she said to my surprise, which left me feeling that she was breaching the trust between us with her usual dishonest wise-cracking; just when I thought we were becoming closer.

'Is that what men tell you? That if you had a "real" pussy, everything would be perfect?' I wanted to distress her with this question because, even though she wasn't trying to hurt me, being on the receiving end of these one-size-fits-all performances always hurts. That's what it usually boiled down to: a vicious cycle of hurting others as a way to protect oneself. Back then, we didn't understand the toll these reactive behaviours took on our bodies and our relationships. We were all chasing some kind of sexual liberation that would finally bring us the relief that we so longed for. An impossible quest because, as much as we wanted it to be otherwise, our sexuality was rarely about exploration, and even less so pleasure. In this deeply conservative and patriarchal society it

became clear that sexuality was firstly a matter of gender, and then domination. Were you man enough (regardless of your gender), assertive and strong and preferably rich enough, to fuck the hottest girls? Were you girly enough, submissive and kind and pretty on the outside but slutty on the inside, for the men to want to fuck you? Lesbians also appropriated the "man-nerisms" of the culture available to them. Georgia was a good example of someone who hated men, but behaved just like them when it came to the display of finer emotions and of desire. We had quite a few tense discussions about her behaviour but, at the end of the day, we all participated in the social charade as, for some of us, doing so made life easier. For others, the dominant culture was so entrenched in their psyches that it overrode any alternative expression of gender, sexuality or desire. This was so obvious with the gays, who, in those days, mostly consisted of really camp and effeminate boys who doted on straight men. Not just straight-looking, but actual heterosexual men, who they hoped one day would just fuck them. Not love them. Fucking was the only love that you could get from heterosexual men as a gay man. Trans women yearned for the same attention, and moulded their shapes according to male desire. So did the sex workers, of all genders. At least they also got money, at times, or favours in return. Sometimes they also had their bodies beaten, for daring to ask for anything in exchange — most often they got beaten for asking for love. No, love was not one of our talents.

That day we spent most of the time talking about fucking, bodies, fucking bodies, beautiful bodies, beauty in general; but all of these conversations barely

scratched the surface of what we wanted or understood to be desire. Nor could we see how it related to the images we were trying to create. What men wanted was so deeply ingrained in us, it would take years to unfasten their illness from our flesh. Only then might we be able to make sense of what we were trying to capture in a landscape barren of any visual culture we could truly relate to. And so, during our photoshoot, Mariza performed exactly what those men understood as satisfying their desire, while what I wanted to capture was someone who hated those men, and, in my young and defiant mind, the only way you could do that was to not give them the expression of femininity that they expected, unless you were intending to exploit them. I was so naïve. They took it anyway, and used you first, regardless of what you were able to express.

I found Mariza's prowess arousing. I reasoned that it was because I could never perform something like it. Or could I? Have I? How many times did we flirt with bouncers so they would let us into clubs? Didn't we put on a particular voice with the bartenders at the rock bar, in the hopes of free drinks? Didn't we smile at the baker when we were short of change? Didn't Jay fuck for rides, for drugs, for love? Didn't Milena fuck for a visa? Didn't I fuck in the hope that, the more I did it, the more I could free myself from the notion that the body is sacred, when it is clearly a commodity. You don't start out fucking for something, but once you start fucking you realise that it's always about something, and that some-thing is rarely pleasure, let alone love. Indeed, when the link between femininity and sexuality breaks, you will either submit to the damage or you will harden.

Mariza stood up and tried to balance on the dilapidated wall in her six-inch heels. 'Shoot me from below,' she said, 'it makes the legs look longer.' I laid down on the ground and pointed the camera upwards, trying to capture a portrait of her entire body. With her legs spread open like a warrior, hands squeezing her ribcage on either side, the palm trees behind her casting a beautiful kaleidoscope of light on her silhouette, she looked to the sky with lips parted. She was breathtaking. As she stood there in her triumphant pose, I admired the contours of her strong thighs and the crescent of her ass. But I also had to warn her,

'Mariza, this shot does make your legs look longer, but it makes your dick look longer too.'

'Shit! Hold on, hold on,' she jittered, as if she had forgotten something crucial. She hoisted up the fishnet dress, fumbled inside her flimsy G-string and said, 'I've tucked it, can you see it now?' I could still see it.

'Maybe we should do both?' I suggested. 'Tucked and untucked?' She looked down at me, almost as if something was made clear to her in that moment.

'You like a bit of cock too sometimes, don't you?' she said, teasing me. 'Yes, let's do it! Most of those faggots want me to fuck *them* anyway, so I might as well show them what I've got.'

That shoot taught me a lot about the power of such images, and who they were really designed for at the time. Mariza also taught me something about that process of becoming hardened, closed, suspicious, permanently alert, defensive, and mistrustful of all relationships, even of those closest to you. It made me wary of what would become of me if I continued to harden. Isn't this what

men ultimately wanted for us? To become so tough that, even if their behaviour became worse, we would be hard enough to take it without breaking. And so, if there is no visible damage, there is no criminal to prosecute. Worst of all, hardening meant that the inability to trust severed the possibility of even those positive alliances with other women, or with the few people who were really different.

We wrapped up the shoot when the sun had almost set. Mariza offered to give me a ride home. As I only lived a couple of blocks away, I told her that I was fine getting home. 'You might be fine but I'm not. You could at least escort me to the car; it's getting dark and there's going to be people everywhere.' This was the first time she'd expressed any vulnerability. We only ever saw Mariza at the gay bar, late at night, and she always seemed to be able to handle the most terrifying and difficult situations that would blow up in there. It would never have occurred to me that she might have even an ounce of fear. We made our way through the alleyways, and I helped her balance down a dirt path to a parking lot by an Orthodox church. With the last flicker of twilight, we approached her BMW. She kicked her heels off, chucked them in the back seat, then leaned against the driver's door and said, 'Sure you don't want to go for a ride? I can pull the hood down and we can drive along the seafront with a couple of beers.' She was flirting with me. To this day, I never understood why she pulled me towards her and kissed me, tongue, lips, wet collisions, her hands down the arc of my ass; she pressed me against her and I felt her erection. I placed my hands on her waist; my fingers entwined in her fishnet dress,

I felt her abs through the fabric's holes, her smooth skin, I thought that this is what it feels like with a woman. She took my hand and placed it on her breast, I gasped, not knowing what to do with this new information. She stuck her tongue in my mouth, licked my lips, my cheek, my face and started to unbuckle my belt, urgently, like if everything didn't happen right there and then, it would never happen and I completely gave in to her, wanting everything to happen. I lifted up her dress and felt her thighs, brought her leg around my waist while I pressed closer against her pelvis with my pelvis, breasts to breasts, mouth to mouth. The lights from the car next to hers flickered and beeped. We heard people walking from the other side of the parking lot. Mariza opened her car door and jumped inside. She lowered her tinted window and, with a cigarette already in her mouth, she said, 'Shame you don't have a cock,' and started to check her makeup in the car mirror, before she drove off without a goodbye.

Next Saturday at the photographer's, I processed the films in the kitchenette. He came up behind me and put his hands on my waist. I thought of Mariza and endured the situation for a few minutes longer. He grabbed my breasts. I protested as if he were a toddler getting in the way of mummy's cooking. He backed off and a little later tried something new, a simple graze, a whiff of my hair, a brush of his knee against my ass, a squeeze of my thigh. I never got used to it, but I tolerated it. I got what I wanted. After a couple of Saturdays, I put the final touches to those prints, and then I didn't show up for work again. He never paid me.

Following that last shift, I went to the gay bar with the prints and waited for Mariza to arrive. I wanted to impress her, to show her how beautiful she was. She never showed up. The owner said that she had already left the country. She never paid me either. A couple of years later I saw her at a trance party. She was pushing cocaine and I was dancing with a girl; the first girl that I would fall in love with, and the one who put an end to the things I could tolerate. On my way out of the club, I noticed Mariza leaning against a broken pinball machine in the corridor. We nodded at each other, like two comrades who had fought in a very unfair war. As I walked past her, she pinched my waist in that way she did to everyone at the gay bar. I grabbed her wrist in a flash, a knee-jerk reaction following years of practice.

'Oooh, someone likes it rough,' she purred sarcastically.

I let go of her wrist and, lowering my eyes, I said softly, 'I'm sorry.'

Her fingers lifted my chin and, when our eyes met again, she said, 'So am I.'

VISUAL PLEASURES

We sat in a cosy cafe, both exhausted from the energy of people, from the circular and heavily charged flow of giving and receiving attention. I had just finished two rounds of coffees with acquaintances, and was wondering how I would choreograph a night filled with even more socialising, more coffees, drinks, dinner, a couple of parties to choose from or to squeeze in; confirmed and unconfirmed settings swarmed with the nattering of predictable lives. My head sounded with other people's words; the repetition of disgorged frustrations and incomplete sentences.

We drew closer to each other, our bodies acting as a buffer against the noise of so many jaws masticating undercooked feelings. Oh lover, I just want to sit still and examine the texture of your skin. To inhale your fatigue and blow it out into the blushing orange sky. In this moment, just before dusk, when little sparks of desire flare into full blown fires, where the blood orange of the sunset meets the deep purple, with your bottom lip brushing the lobe of my ear, you whispered, 'Let's get out of here.' You drove. Fast. Sturdy. Focused. Driven. I took a deep breath when you hit the motorway, and exhaled when your speed climaxed to 150 kilometres per hour towards a Deep Purple concert. I observed the movements of your strong arms shifting gears, your hands so calculated — calculated and never in excess. The crimson sky behind us, I fell in love with your slender fingers gripping the steering wheel, just like that first night together when you

drove us to the beach — that specific beach, because no other beach would do. You had the type of determination that could decide the course of history through its sheer resoluteness. Do you remember how you tried to slip your hand into mine while we sat looking at the stillness of the moonlit sea on a cold night last autumn? You chose that set as the location that was going to detonate our affair. 'That's not a good idea,' I said, springing off the pebbled shore and away from you. 'I'm numb. I can't feel anything.'

I know that you still hold it against me. Rather poor judgement on your part, considering that only a few days later we slept together. I was rightfully cautious. It had to do with the way you would look at me, such hunger that I often felt your voracious inhalations were sucking the air from under my careless gait. You wanted a taste of freedom. I wanted the abundance of me to be consumed. I offered up my flesh. You never told me that you would invite all your demons to the feast.

How could I trust you, when doing so meant I would violate my primary rule: sex in freedom or no sex at all. My rules. How guileless I sound. As if little me could possibly exert any influence over the customs followed by the people of an entire country, customs that took entire generations to cement. I used to feel sorry for those who suffered the adverse effects of having, or choosing, to be in my company. Effects that ranged from envy and disdain, to guilt or thrill by association. What transpired was that "my rules", my very presence and half-baked ideals on this island, were considered a public anomaly. Effect is not quite influence.

That night on the beach, I was too wounded and insecure to embrace the possibility of yet another

impossible relationship. In my experience, they all followed the same course from promise to pain, until they made me uncomfortable, then afraid, and finally numb. I had not felt anything for months, after my last attempt at an affair, which had failed the feasibility test from the outset: she was married with two children. I had not felt anything until your touch unexpectedly galvanised me. Until, and I catch my breath every time I think about this, until your fingers — electric; the precision with which they moved — spellbinding. Despite all the reservations I had, I couldn't stop myself from kissing you, knowing it would cost me everything while wanting both of us to believe that it meant nothing. What lies between everything and nothing?

It's been six months since that night on the beach, and it's the first time that I have the urge to take a photo of us. Something that I rarely ever do anymore, but this time I needed to; I needed to substantiate that this was really happening between us. It was happening in a public space, in full view of all these people. I wanted to remember, years from now, I wanted to recall that specific moment, the chilly breeze of a warm night, the goose bumps on your neck, all those knees moving back and forth to the lyrics, all of us sharing a public experience, a public display of feelings.

I couldn't wait to call Jay and tell her everything. To tell her how this present experience, the joy of owning the streets, casts a line into the depths of our past together and hooks onto so many life-affirming memories. I am almost certain I have photographed Jay blowing out smoke hoops during one of our daily loops of trivia and spleen-splitting laughter. The bike rides,

rollerblading, reading under trees, bunking off school, getting high, getting by; by lying, cheating, stealing, living hard and fast because we knew of no other way to live. All these experiences run through my mind like a carousel projecting grainy 35 mm black and white photos. When we were teenagers we promised each other that we would continue hell for leather, even if it meant we would have to die by the time we reached our thirties. We survived.

I wanted to tell Jay that the intensities are still the same. I wanted to tell her that it's the first time a rock band we used to worship is performing on the island, and yet, what matters to me the most in this assembly of people and moments is the one heart that drove me here. One heartbeat, steady and mighty, louder in my ears than the deafening drumroll rumbling from the stage. It's how I feel when I'm with Jay. No one else and nothing else matters when the closeness of our bodies is precisely the matter of our dreams.

I pulled my phone out and slipped my arm around your waist, screen facing us. You stuck your tongue out and so did I. Our tongues met at the tips and the click froze the encounter. This was the only photograph that I needed from tonight, to capture this twinkle of freedom, and relish it from time to time. To recall that, until this point, I have only known the shell of you, even though I keep on crashing into your untamed depths. Forgive me for wanting to dive in and out of you like an agile sea creature. I just want you to see the glitter on the surface of the sea. I want you to savour my skin in the light of the day, by the sandy shore, in the bustling cafes of the square, against the graffitied walls of the old town

centre, where mothers and migrants scurry towards the market. It is not that I have problems with domesticity, as you once diagnosed; I have a problem with palaces that become prisons. While you intoxicate yourself with the liquids of our furtive lovemaking, your ravenous hands trembling at the surplus of my curves, I dream of holding your hand in the sun. Forgive me. This body that you so worship has endured unspeakable crimes, just for attempting to walk freely under this sun.

After so many years away from here, and with the clarity and reparation that distance affords, I have conquered the sun and I want to share it with you. I want to savour my fifteen-year-old self emerging anew in the body of a thirty-two-year-old girl. Tender, hopeful and full of trust, I want to live out the innocence that was prematurely ravaged when this body inadvertently became a public affair. I feel an unprecedented light-ness this summer, remembering how this island shaped me, why it made me who I am, why I had no choice but to turn angry and rebellious. This wild heart and critical mind are the result of the constant harrowing experiences that I endured but outlived. Where were Deep Purple when we needed something to worship?

During the 1990s, we only had a choice of two smoky bars where we could experience rock music, from the (dis)comfort of a wooden bar stool. After three hours, three pints and three tequilas, the music would amplify in intensity. It trickled into our drinks and distilled our slight limbs into a ferment of pleasure and exhilaration that could only find release in movement. We would

join the small crowd of fellow lost souls, who overcame the flatness of life with the kind of sorcery that only music flowing through your veins can produce. A hammering so intense that it would turn you numb. Numbed out of feeling. Perhaps this was the unattainable cause that drove us to test so many of our limits: how to feel more intensely when we were already numb from having felt too much too soon.

It was seventeen years ago when, leaving one of those bar stool nights with Jay, we were approached by a dealer. 'Ladies, I've got some fiiiiine weed for you,' he said with a big smile, to conceal his desperation. I grabbed Jay by the arm and stopped her in her tracks. She looked uncertain. But we were always uncertain when it came to what adults do.

'How much?' I asked dryly.

'Lemme show you! You wanna see it? It's over a gram. Smell it! Go on! Smell it.'

'How much?' I repeated, while his fidgeting fingers unravelled a piece of mangled foil.

'I'll give you all of it for twenty!'

'I'll give you ten.' I said, poker-faced.

'What?! Did you see it? Did you smell it, this is first-class shit! This is... '

'I'll give you ten. Take it or leave it but stop wasting our time.'

The first-class aluminium sachet travelled around in my school bag for a couple of weeks. Until we were taken to a local protest, disguised as a school trip, in the town centre. Wearing our good-girl uniforms, we sneaked into the toilets of a posh cafe. I rolled my first joint as if I'd always known how to roll joints; as if I

instinctively knew the ways of aluminium-wrapped dreams. It was in this toilet that us good girls went to heaven — first-class. We didn't need the deep purples, the mellow yellows or the fiery reds anymore — we found something to worship. And it was during that school trip that I saw him for what I thought would be the last time. We never returned to the protest; instead we walked around town aimlessly, and happened to be outside my uncle's house as he was descending the external staircase. 'And who are you?' he cajoled, with that recognisable cheeky and charming smirk on his face, even though he hadn't paid child maintenance for over two years. I wanted to tell him everything, to tell him about all the months I had worked so hard to turn the memory of him into nothing. Between everything and nothing lies the rehearsal of a life temporarily suspended.

'I used to be your daughter… '

What women say is sometimes less important than the mere fact that they are daring to say anything at all. On the contrary, men, especially men of his kind, will say anything that comes to mind, in any given space, without any pause for thought. My response inflamed his charm and cheek into a blazing rage. He dragged me into his brother's house, sat me on a chair, and shouted at me for what felt like an excruciating and interminable, economy-class long-haul flight. I do not recall his words because it mattered so much more to me that I would remember mine. I was high. For the first time, I had found some-thing that gave me the courage to speak my truth without fear. I was so high. My heart raced but my mind was level. I felt everything physically and experienced

nothing emotionally. It turned out that numbness was a prerequisite not only for survival, but also for public speech. Now I could finally effect the latter.

I performed the lines from the script I had developed and rehearsed since my mother and I left him. A block-buster that I imagined would be a pivotal, ground-breaking work of art and glory one day. That glorious day came sooner than I expected.

INT. UNCLE'S LIVING ROOM — DAY

 MAIN CHARACTER
 I understand that you had a lousy
 time in jail Dad, but you deserved
 to go there after the way you
 treated Mum.

Observes former father's lips quaking
furiously under his full beard.

 MAIN CHARACTER (CONT'D)
 I will never forgive you, because
 you will never be sorry.

 FORMER FATHER
 (shouts incomprehensible
 sentences that include the
 words 'your mother' and
 'whore')

MAIN CHARACTER
Don't you dare call my mother a
whore again, when it is you who
should be ashamed of yourself.

Watches the pulsing vein on his forehead,
right next to the deep scar caused by her
mother's stiletto.

FORMER FATHER
(Continues to shout and
punch his fist into his palm)

MAIN CHARACTER
You can bang your hands together
all you like but I just don't want
anything to do with you or anyone
like you. Look how ridiculous you
are.

'I understand that you had a lousy time in jail Dad,
but you deserved to go there after the way you treated
Mum.' *This* is cinema. I observed his slim lips, quaking
with fury under his full beard. 'I will never forgive you,
because you will never be sorry,' I insisted, while he
continued shouting incomprehensible sentences that
included the words 'your mother' and 'whore'. 'Don't
you ever dare call my mother a whore again, when it is
you who should be ashamed of yourself,' I said firmly,
and watched the pulsing vein on his forehead, right next
to the deep scar caused by my mother's stiletto when

she once managed to kick him in the face. He just carried on shouting and punching his fist into his palm like an ape trying to crush a peanut. 'You can bang your hands together all you like but I just don't want anything to do with you or anyone like you. Look how ridiculous you are.' I hoped for the vein to burst. He could snap me in half with his arms but I had the power of words, and I was aiming to split his forehead in two, to finish the business that my mother hadn't. I am high and this is the most riveting movie I have seen. And I am directing it all — his anger, his bulging veins, his arms clenching, coming towards me and stopping at the perfect moment. I was in control. I knew the breaking point. I knew what to say to break and fix. Cut and edit. Rolling, panning, tracking. I didn't want to forget a single word, frame, sequence. Perhaps I would have been happier if I had.

'I'm tired of analysing everything,' you said in the car on the way back from the concert. 'I feel that, since I met you, I'm analysing everything but enjoying nothing. I kissed you in public for that photo because I was sure no one would notice. And what does our status matter anyway? You'll leave again after the summer.'

You often mistake analysis for criticism, but what you really mean by criticism is judgement. I take criticism to be a form of loving attention, an action that arises from fidelity to a meaningful matter or person. But analysis is just that: an analysis; a relief from the absurdity of living in perpetual motion without meaning. In other words, how long do you think you can go on fucking me before everyone finds out?

While I drove us back, you fell asleep in the car — motionless. I shifted gears gently, braked far ahead of time to ensure a smooth lullaby. I watched you, unguarded and precious. You will never know how my eyes welled with the desire to spoil you, to cast spells that would shield your body when the troubles came. To protect you and wrap you in my newly found colossal strength. I recalled how, during one of our break-ups, you pleaded in excess of your usual self: 'I want to be your everything! I want to be your mother, your friend, everything!' How does everything represent? Your omissions were as important as your submissions. A mother and a friend, yet after half a year in this obsessive and all-consuming affair, you still couldn't bring yourself to say the one word that mattered: lover.

I have two shattered pillars in my foundations: a broken home, considerably eroded by a broken society. I heard that she had a fascination for damage and danger — I never found out which attraction came first. I warned her that the broken ones are stronger. The smaller the pieces they were smashed into, the harder it would be to shatter them again, but also the harder to piece them back together. I used to marvel at her delicate fingers long after she had gone. I would fantasise about how she could reassemble my little morsels of brokenness into a once-impeccable togetherness. To pull my dispersed (im)perfections into a composition that she liked. She liked me to submit to her. I liked that she needed my submission. I liked the fantasy; being able to let go and hand my body over to someone else for a little while. But this didn't pan out so well when our bedroom activity slipped into real life. My sexual compliance

should not have given rise to the contentious expectation that, in real life, should the occasion somehow call for it, I would be emotionally submissive. A tricky thing to ask of someone whose mother was never the prototype of saintly devotion or selfless sacrifice. Our relationship soon developed a predictable pattern: I would need to run when something reminded me that I was trapped in the secrecy of her bedroom; she would then use various methods of control to make sure I stayed put. As our sexual activity enacted similar patterns of behaviour, I struggled to delineate what was consensual role-play and what was a fully outlined profile of abuse.

While being broken consumes a lot of energy, it takes even more strength to break out of a broken state. Sometimes it takes more than one has and, often, it takes more strength to ask for help than it does to be strong. I had a strange premonition that night, and I expressed that I wanted her to stay the night, but she wanted or had — I could rarely tell the difference — to stay with her family. A family that I knew everything about, but who knew nothing of me. She kicked up another epistemological argument about her belief that the intersections between love, sexuality and intimacy can exist outside the public realm. 'I love you! Is that not enough for you?' she stated as evidence. How can love exist outside the public space? How can such an experience be love, when it lacks the very condition that makes justice, ethics, freedom, a relationship between two people possible? I didn't get upset this time. Perhaps it was the desert dust around the moon, hazy and languid, portending a slow change of some kind, that assuaged my otherwise dissentient attitude. I didn't have

the patience for yet another irrational battle. In the battlefield there are only enemies or allies. If she is my ally, why do we sleep in separate camps?

The next morning at Aunty's house, where I often stayed during my summer visits, I woke up in my single bed without the lover's body resting next to mine. I heard voices from the kitchen. Male voices. Why is it that, when a group of people sit at a table you can only hear male voices? Am I being selective in my hearing? I remained naked and immobile in my tiny bed, craving her solid, muscular presence to embody the fortitude that I did not have. I felt smaller than a termite on a sinking raft of timber. Had she stayed, we would have woken up earlier, we would have already been out of here; we could have been at the beach. It's not her battle. I must fight this. I am not upset because, ultimately, neither of us should have to live in camps. We should live in sanctuaries of love. On this glorious morning my mud-brick sanctuary was invaded. Right outside my room, preparing the spit for a meat feast, I heard his voice.

Suddenly, I could remember things that I thought I had long forgotten, sounds from the time before my mother and I escaped from him. The way he would inhale his cigarette as if the smoke had to squeeze through his wide gum holes and gritted teeth. The inaudible rubber of his shoe soles was now magnified, and I remembered the coordinates of his walk so acutely that I could hear the caoutchouc pressing the earth, sole first, then toes, not the slightest drag or clumsiness. What kind of man walks like that? I heard the way his hands slapped the meat onto the table before finding the right spot to pass the skewer through. His hands slapping the meat

sounded like a tender version of that day when he got out of the car, walked over to the front passenger seat, opened the door, yanked my mother out by her hair and slapped her across the face, not once, but enough times for her to fall back into the seat almost unconscious. Sitting in the back, I had no clear view of what was happening, but the sound was exactly the same as that piece of pork. I was so alert, I could detect that the meat was in a metal dish on a plastic table in the garden, not in the middle of the table but towards the bottom left corner. Still lying on my bed, the noises from outside amplified to such a level that they overrode the palpitations of my heart; they outweighed the ringing in my left ear that sounded like a metal rod scratching a sheet of bronze; they dulled the rustle of my thumb nervously caressing the corner of my linen pillowcase. Then I blinked and it was as if I had gone deaf, sound switched over to sight. I visualised charging the stainless-steel skewer, through the loamy kitchen wall, right into his gut. This fantasy shattered into the realisation that, in fact, I was the one trapped.

Out. Fast. Really fast. Out. Don't panic. Just get out. Go. Go. Go to your friends. As far as you can. Where is she? Why isn't she here? Inhale, inhale, and inhale. Get out fast. Let it out fast. You're going to have to exhale. Forget about your stuff, you don't need anything, ever. Clothes. What clothes? Slut. Slut. Show him what you are. Strong, courageous, proud slut. Where the hell is that sexy t-shirt with the open back? There! No bra, hot pants, leather, leather anything, sandals, flick the hair, inhale, smile at the mirror, don't smile at him. Walk out, walk away, walk on and let him stare at your back. Don't

look back. Let him watch everything he had walk away from him one more time. I have my mother's back, her catwalk, her slim waist, full thighs and supple limbs. I will embody her, an embodiment from before the time he broke her. Shoulders straight and majestic. Chin high, royal nose, the eyes of empires, aristocracies and ruthless warriors. The type of eyes that can seduce every rival and win any battle, through the centuries, through the dense matter of time, eyes that strike out victorious and enduring. This is what walking into infinity looks like. Oh lover, do you still think you could be my mother?

The rusty iron knob of Aunty's wooden door glared at me. That door has seen it all. I imagined the handle would be hot and heavy with the weight of knowledge, with the pressure to burst open onto… *Daddy*.

Heart pounding so fast, I could almost hear the blood circulating in my neck and temples; I expected my ears to leak with haematological vowels of dissent.

'Goodmorning,' I said firmly, making my way out, once again, into the safety afforded by the streets. I felt his eyes like razorblades, cold against my back.

'Goodmorning,' he said.

Seventeen years since the last time I saw him.

And who are you?
I used to be your daughter.

Goodmorning.
Goodmorning.

Seventeen years later and these are the only words that remain.

What women say is sometimes less important than the mere fact that they are daring to say anything at all.

HEAVENLY SMELLS

'Goodmorning! I know that you warned me, and you definitely won't approve, but you know that closeted lawyer that you told me to stop having sex with... well I…'

'That lump in my breast, it's cancer.'

'OK, you win.'

Jay has breast cancer. Cancer in the left breast. Jay has beautiful breasts. 'The perfect size and shape for white tank tops, that's why you like them,' she would tell me every time I commented on the flawless fit of her shirts. My best friend, my ally, my sister Jay has breast cancer. She is nearing her mid-thirties. Jay, my eternal friend, now has breast cancer. Cancer. Breast. Mastectomy. Chemotherapy and mastectomy. 'It's not just any cancer, it's Angelina Jolie's cancer,' she jokes. Which means that women who are serendipitously born on that side of life will very likely, at some point, develop this type of cancer. Her sister could have a tumour, their cousins too. Jay also has a thirty per cent chance of ovarian cancer within the next ten years. Best to remove everything: breasts, ovaries, the works. We don't know yet. Appointments. More genetic testing. Scans of all kinds. Step by step. First things first. One breast. Let's take it from there. Women are advised to do a breast reconstruction at the same time as the mastectomy. 'They might as well chop them both off. Never liked carrying them anyway,' she tells everyone with such confidence, a sharp assertion that pierces the sides of my ribs, every time, in the exact same way.

Jay, oh my love, with breast cancer. Your braless breasts bobbing under a t-shirt, nipples erect while we walk hand in hand down the street, scandalising the shopkeepers and staring back at the coffee drinkers who sit around ogling every single pedestrian in the hope of some mental stimulation. Your breasts, soft and familiar against my back while riding motorbikes over the years, while you cuddle me, arms encircling my waist, crotch against my butt, your thighs aligned with the length of mine, talking into my ear, my good ear. Your bosom casually resting on my spine when you sit on a stool behind me or when you spoon me in bed. I think of the ways your breasts have changed over the years. Remember the day you realised that you were no longer a 34A bra size but a 34B? That was your size from then on, apart from that time you had the abortion in the second month and you went up a cup size. Oh, and I almost forgot that period when you put on weight from the contraceptives — it took you half a year to return to a version of yourself that you were familiar with. I had never thought about your breasts in so many different ways. Your breasts against my breasts every time we meet and you hold me closer than anyone even though I saw you only yesterday; you squeeze me with such passion that I know everything will be fine, no matter how bad things get. Freedom is the dome-shaped pressure of your breasts against me, under the sun, in public, with all the contempt that the public had for girls riding bikes. Your head leaning over my shoulder to tell me stories while we ride, stories that tickle my cheeks like butterflies before they disperse into the aether. Complete abandonment is the sensation of those breasts

124

against my back, spinning circles, drumming with the beats of her heart, the reverberations of her love. Desire is a circle, the repetition of devoted attention, a loop, continuity without cessation, boundless and infinite and ever-present even in the absence of faith; in the painful, crushing life events, circles continue spinning our lives onwards; onwards and forward, as hard as it may feel in the moment, the fullness of time is destined, intended, let go, let it go — you cannot control this.

I have known her body; my body has grown side-by-side with her body. From the age of ten, I have seen every single expansion of her anatomy, her legs getting longer, her fingers more crooked after years of basketball and nail-biting, her hair becoming long and short and mid-length and straight and curly and dyed, the first grey hair, and I remembered that time when I shaved it all off for her after she lost our bet. Her neck and her Adam's apple and her collarbone adorned with so many different necklaces, from gold to cheap silver, to that ugly seashell she insisted on wearing on a chamois string, even when it gave her a rash. I remembered the rash, that one and all the others; the one from the stray cat that rubbed against the side of her knee, the one itching the webs of her fingers from the milk of figs that we stole from that rich lady's garden, the rash on her calf after the burn from the motorbike exhaust; you can still just make it out if you look closely. The two different types of rashes each associated with a particular STI. The rash on her back from a filthy lake in Portugal, the thing that looked like a rash on her abdomen, that turned out to be bedbugs from that cheap hostel in Belgrade. I know her body, *I* know her body, how could I not have

known about the lump, how could I not have done something earlier?

A few weeks ago, we went swimming right after I picked her up from the airport. We were sunbathing topless. Why hadn't I noticed, why hadn't she noticed, does she even notice her body? Especially now that she is seeing this random guy she met a few days after she arrived. Just another guy in the series of guys. There is always some guy, and when there is no guy there is me. Do they even look at her, these guys? Does her collarbone mean anything to them, do her breasts mean anything to them apart from some porn prop? Will they ever know what it's like to have cried rivers on those breasts, to remember all the times they soaked up my desolation after each catastrophe that would happen to us and wouldn't stop happening to us, just because we were girls, we were different, we were foreigners. I was damned for being born here and she was born with this damned thing. As if everything else were not bad enough, just when you think that you have gained some ground and repaired some of the damage, another disaster strikes.

Here I am once again, Jay's personal liberation squad, only this time it's not some guy that she needs rescuing from, but something that I cannot in any way save her from. Sitting here, in her parent's kitchen, her mother tends to the *kolokasi* (*taro stew*) and murmurs 'God willing…', and I smash the plate on the kitchen floor because I can't find this god whose face needs smashing for willing.

I apologised about the plate. 'It was an accident,' I mumbled, and made my way to the garden shed to get the broom. I lifted the latch, bent over to pick up the

dustpan and saw my tears landing on the floor. I can't cry now, not now, she needs my resilience, to get her through this, as we have always supported each other through things. I have to be strong for her, to hold back the tears that form every time I think about her breasts, because now I have associated them with crying and not with all those other things which we agreed breasts are: clusters of fat, capillaries, arteries, tissue, and milk ducts that neither she nor I wanted ever to use. Useless. For some people they are just a burden. She never liked them anyway; she hated it when people touched or licked them. Deep breath; 'we will get through this,' I tell the earth, and walk back into the kitchen to sweep up the plate, while she lays the table for us to eat before leaving for another round of blood tests. Just another day, another meal, another event in our lives. Does she know how much I adore her? Every single part of her, her breasts, her nipples, her areolae, all of her. I adore her breasts because they are *her* breasts. Her boobies. Her bosom. Jay's boobs. Her titties. Tits.

'Fuck these tits,' I moaned into the lover's neck. My arms around her shoulders while she pressed onto me. She gently bit my nipples. Pinched them. Then held my tits together in one hand while she took me up against the black marble tiles of her bathroom. We then moved from the shower to the bedroom, onto a mattress certified by a space agency, worth almost half a year's rent. That mattress was the closest my skin has ever been to wealth. Her sweaty body slithered in rhythmical movements up and down my flesh. Hair, tongue, sweat, spit. Human fluids,

liquids, stuff, the stuff of another body against my own, drenching the sheets, soaking through to the lavish foam.

I ran my hands down the length of her spine and reached the puddle of sweat forming at the crevice of her lower back. Opulence. Every time her swollen clitoris pounded mine, the puddle tremored and drops of sweat escaped, rolling down from her back to the sides of her waistline, landing on my belly. With her every thrust, the droplets slowly dribbled closer to my bellybutton until they slid in there, creating another well of pleasure. Splendour. These are physical tears of joy. Tears of vitality. Life slipping into me, one finger, two fingers, three fingers, more, more. I wanted her fist inside me. I wanted her to stick the length of her arm so deep inside me that she would reach my guts and fill me up with her vigour. But she didn't. I wanted her to reach in there and rip out the pain. But she couldn't. While I lay there fantasising beyond the bounds of reality, the truth of the matter is, I felt nothing. Nothing, no life, no beat, nothing. I was full of nothing. I stared at the ceiling fan; its slow gyrations calmed me. I tried to think of continuities, futures untold, possibilities that could unfold while she penetrated me in a rhythm that perfectly complemented and contrasted with the sedated rotations of those metallic blades. Closing my eyes, I rocked to the flow of her body on top of mine.

'Slap me,' I pleaded.

'Emm…'

'Slap me… please.'

'What do you mean?'

'It's a two-word request. I don't think I can simplify it more than that.'

Gently, she stroked my butt gently, for a moment I thought even lovingly. Nothing. I felt nothing. She squeezed, tenderly, as if she were inspecting the ripeness of a mango. Nothing. She patted it. Like she did the watermelon yesterday afternoon at the grocer's, tapping to detect that specific sound which is hollow yet bursting with ambrosial plumpness. She slapped my ass, thank heavens, a morsel of relief. I urged her to go harder. She did. I wanted to bruise, to hurt, to weep the fear out of me. I tried to relax, to let go, to stop myself from thinking, to inhabit a physical pinnacle that would override any thought. She slapped it again, a little harder, and I heard her suck in her breath. In that moment, I sensed her own fear and I became preoccupied, like I was trying to solve the coded messages of her body. I could almost hear her thoughts. Not thoughts exactly, but the language of her body producing so many shudders of desire enveloped in guilt and shame that if those quivers unwrapped into words they would muster: 'How do you go back to having sex like you used to when you have just gotten off on fucking her like this? What was sex before this? It's okay to slap her, she likes it, oh my god I've never done this before, this is so hot. She wants it, she wants it real hard, give it to her, come inside her, all over her ass, all over her, she wants it, slut.' She let out a groan so deep it reminded me of our local zoo when they still had lions, and every night you would hear a single roar that was the accumulation of despair of an animal that had suffered yet another day in captivity. For a moment, I became aroused by her herculean orgasm, but the moment was too short. Within a couple of minutes her body returned to that withdrawn state that required

detective work from my side, work that turned my own body into a lighthouse, perpetually on the lookout for some sort of signal in the mist of our lovemaking. She tried to continue, to please me, not to leave me there unclimaxed. She started by fondling my breasts again. Breast cancer. Jay has breast cancer. She licked my nipples. Mastectomy. They will need to remove the breast. She bit my nipple. I felt something. A kind of emptiness. We stopped.

'Are you ok?' she asked, trembling a little while trying to appear unflustered and confident.

'...'

'Are you ok?'

'Yes.'

Yes. *I* am. But Jay has breast cancer. I feel something empty, as if I'm stuffed with an emptiness. My body, that vibrant matter called the body, now feels so full of emptiness, like there is no life in it, only a hollow feeling, even when other vibrant matter slithers up and down it. There is only an overarching and unbearable emptiness that compels you to take your body beyond its usual limits, with the intention of feeling something, anything at all. Until that something that you feel is an emptiness. Slithers, rhythms, vibrations, things, nonsensical things. No life. No. Nothing. No thing. Negation.

No. This can't be happening. You can still make something out of nothing. Remember, Jay? Every time we reached mind-numbing boredom, we used to say, 'No-thing is still a thing.' You always made something out of nothing. You breathed life into nothing. This island has given us nothing and yet we have made so many things possible because we had nothing better to

do. And unlike everyone else, we had nothing to lose. I'm so fucking afraid of losing you. I can take anything else, I can go through so much worse, I can do everything and anything as long as I can come back to you, to know that it all matters, or that it doesn't matter, and what really matters is another day that is worth living, fighting, hustling, so that we can still dream together, imagining that better worlds and lives are possible even when everything around us is prosaic at best, unparalleled evil at worst. There are always those moments we create together that rise above it all; I don't know what to call those moments, magic? Yes, that's it, our chemistry, the proximity of our bodies brews an exceptional sorcery, our actions so impulsive and perfectly in sync, they were the enchantment that kept us safe. Growing up here, together, making it through high school, eventually escaping and surviving, was in itself a supernatural act. We should have been dead already.

'Are you ok?' the lover whispers, still caressing my ass.

'I can't feel… anything. Maybe we overdid it.'

I think that might have hurt her but I didn't know how to speak about the last few days and the impact they'd had on me. I had never felt so completely helpless. I couldn't even bear being in my own body, and there was nothing to slow down the speed with which the thoughts fired in my head. I gave her a deep kiss and told her that everything is so good and luxurious here, that it makes me a little emotional. To some extent, this was true. If I had to cut through all the bullshit, her machismo, her repression, the coolness that disguised her ingrained puritanism, the lies she told herself and

others, the obstinate and baseless ways in which she defended her lying, so as not to expose her weakness, her fragility, her lack of confidence everywhere, from the workplace to the bedroom; if I were able to just swim through the cascade of her accumulating contradictions, I would see that she cared for me, perhaps even loved me a little. Is this what people mean by low standards?

I was tired of swimming against the tide, making it through, trailblazing all the way to the other side of persecution, to other countries, in search of the other lives that I wanted to be living, when all I have ever wanted is to be amongst people who can understand me. So we can lift one another up and motivate each other during times so congested with sorrow and anger. That is the antidote to the incessant tyranny of lives less fortunate. Lives where the standards are not only low, not only short on essentials — those we could always steal — the standards lacked the basic components of the flourishing that comes with quality of life. I wanted someone who shared a passion for precisely those things that are not considered of vital significance, but without which one might as well die: ideas, beliefs, justice, culture, humour, creativity, pushing the boundaries of thought and action to feel, even momentarily, that you have felt what all those writers meant by that dubious abstraction or privilege they called "freedom". A freedom whose condition is the possibility of action in public space. Someone to return to who is not like ordinary life, a refuge outside the pressures of everyday demands, away from all the cruelty that comes with the public sphere. That's exactly what Jay has been for me throughout the years. At least there was one person on this island on

whom I could model something positive, something that I believed in, something that seemed to be completely missing from people's lives — love. Maybe even that mystifying feeling we share when we are intimately connected to other people — happiness. That peculiar and unique composition of trust, attention and devotion through the dissonance. How do you explain this to a lover who offers you the highest of living standards but deprives you of any public recognition?

She brought me strawberries in bed and went back to the kitchen to make coffee. It was only 7 am. I hadn't woken up so early in months. We'd had sex just before midnight the night before, she then woke me up at 3 am for another round, and was up like a snake staring at me in her space bed at 6 am, when she decided to take me in the shower. Yet I didn't feel tired. I was so alert that I couldn't relax. I wondered which one of us was really the lion in captivity, when it was I who felt so powerless.

I smelt the coffee brewing in the kitchen, sharp, robust and alive. It occurred to me that, since last night, despite the damp sheets and downpour of her sweat, our ejaculate, our saliva, the lava of all our lovemaking, I couldn't smell anything. I reached for her pillow and sniffed it. I removed the top sheet and noticed a patch of moisture in the centre of the bed and put my nose on that too. She walked in at that moment.

'I love the way you smell,' she said, smiling. 'I'm not going to change my sheets for a while. Unless you're coming back… but who knows with you.'

She put the coffee down beside me. I pulled her closer and stuck my face on her pussy. There it is. Life. I could smell life, the acidic and sea-like saltiness of

her pussy, the remains of my alkaline juices, an ocean of fortunes and futures. It's a new day. I grabbed the strawberries and coffee and went to sit on her balcony. She hastened after me when she realised that I wasn't wearing panties and had only her t-shirt on. She brought me a pair of shorts. I placed them on my crotch and continued to roll a cigarette. I texted Jay that I would be over in an hour to accompany her to the rest of her examinations. I became aware of the smell of my sweat, cidery with a dash of fermented sugar, like a rotting strawberry. It was the smell of fear. I wondered if that was the odour she loved.

Just after that carnal marathon I met Jay, and we spent an entire day rushing from one appointment to the next. We laughed a lot, as we usually did when faced with moronic bureaucracy and folk from "the real world". Somehow these people were so numb from all the illness they had witnessed. It was almost a relief to be treated with apathy, like just another case, and not the maddening emergency going on in my head. Seeing the surgeon first thing in the morning alleviated some of the devastation. He made it sound like a simple procedure, just a set of protocols that must be followed to restore one to health. But I think the important part was when he said, 'What perfectly shaped breasts! You have nothing to worry about, I've done so many of these jobs that I can guarantee the breasts I will create for you will look even better. We could even go up a size if you want.'

Jay looked at me in a way that only I could unravel, our secret exchange of gazes, and in her usual caustic

tone, she said, 'Doctor, why don't you give yourself a pair if you like them so much?'

He was a young doctor, early forties, with a full mane of salt and pepper hair which was probably what he thought made him attractive. With a look of earnest confusion, he smiled and just stared at Jay as if she had made a failed joke. It was unfathomable to him that a woman her age could say something like this and mean it. It was still more unfathomable to him that a woman could say something that was beyond his comprehension, because men like him, men who have the god-like power of shaping bodies and lives, understood everything — so he carried on smiling, politely expecting Jay to make herself clearer. We looked at each other and chuckled. I realised that, even during this fucked up thing that came out of nowhere, we would deal with it the way we always dealt with everything. It was just one more thing to get through; like all the other disasters, it too bore the brunt of the island, and so we would overcome it in a style that was entirely our own and completely antithetical to everything and everyone around us. This was our power, a power we cultivated day after day, and the one which reassured us that we were indeed the sane ones in this society. In this alienating aberration that we experienced as public life, we were actually free because of our alienation. Leaving the surgeon's office, Jay provocatively ruffled his hair and said, with an undertone of flirtation, 'Doctor, what makes you think I ever wanted these bulges on my chest? I'd much rather look like an Amazon than a TV caricature. See you next week.'

I finished up with Jay around 6 pm, and she dropped me off in the town centre so I could meet up with our

friends, while she went to see her new boyfriend. She stopped the car in the middle of a narrow street and, in total disregard for the line of vehicles piling up behind us, she took her time to hug me, kiss me, and hand me a plastic container with her mother's delicious *palouze* (*grape juice jelly*). She then rummaged inside her bag and said, 'I don't think my tits need these right now,' passing me her cigarettes and hugging me again until a driver started honking and swearing at us. Once out of the car, I still carried the smell of Jay's temples and her neck. She has been using the same shampoo for as long as I can remember. All the memories that her scent awakened made me emotional, teary and wistful for something I couldn't exactly recall, even though my mind felt so compartmentalised and vigilant from all the high-alert activity. Was it a period of time? A specific occasion? What memory from our shared history was I grappling for? I say memory, but it would be more like an impression than an exact recollection of an event within a linear temporal sequence. Her scent evoked a sensation, not a memory, from childhood to the present moment, and what I longed for was fearlessness. At school we were frequently reminded that faith was the opposite of fear, so much so that, even when we had lost our religious faith, we remained fearless. It was her scent that made it clear to me that the fearlessness we embodied was the effect of our union, a faith *in* our union, at a time when our faith in the world was gradually disintegrating.

The evening was sticky with humidity, but not as hot as the last few days. I walked past a row of green rubbish bins that emitted the usual miasma of rancid food and

cat spray. I sucked in the smell through my nostrils and closed my eyes in delight. I was inundated by waves of intimacy and adventure. This arresting, bodily awareness of our togetherness flooded me, and, despite the melancholy that came with it, it also rekindled some sort of hope. The fumes from the charcoal grills revving up for the night lingered in the cobblestoned streets. I lingered with them, carried by them, lighter than I had felt all week, since I first heard the news. I was still a little numb, shocked maybe, but my senses were slowly turning towards life. I felt a little hopeful, a hope that stemmed from the fully grasped awareness of being alive in the present moment.

I arrived at the cafe and when I saw the anticipation and sadness on the bewildered faces of our friends, I cried. They all stood up and we had a group hug.

'It isn't the first time, and it won't be the last time Jay does something stupid that we all have to deal with,' Georgia said. I laughed above the tears. We were consoling ourselves because, once again, Jay had brought us all together in a shared state of emergency, and I asked myself what my relationship with our friends would be if Jay weren't the locus of the love and frustration that bound us together. We sat round a table. We have spent days, months, probably entire years sitting around a table, plotting against the world. If our habits and tastes became more eclectic through the years, our expressions conversely became so unique to each one of us that they were almost predictable. And yet, we were changed, the world around us had changed, continues to change. We reflected on the transformations, starting from the cafe where we were sitting, and how the furnishings

and clientele were different. We have had this discussion before; almost every summer we gather at the same cafe and I find that each year we talk a little more about the past than the future.

We always joke about how one day, Georgia just took the police exams to spite Milena's husband, and a year later found herself working in the cybercrime sub-division. Milena had an unwanted child, got divorced, started working at a hotel spa which she is now managing, and which has attracted the most diverse clientele, from Russian oligarchs to transgender people. She and Georgia have fallen out numerous times over the two decades that we have known them. They have rarely met up these last few years, but they will sit around a table together when either Jay or I visit. Tina has three kids already, something that none of us would have expected, and she is still making up excuses for Jay. Pambos became a good friend, and he keeps us informed on the local gossip. He had a theory that the clientele at the gay bar started to drift away when Section 171, the piece of legislation that made it an offence to practise or even promote homosexuality, was repealed. The bar shut its doors a few years ago and we have had very little news from any of the regulars. Times have changed and are changing, with the elimination of gay bars considered a sign of progress. I wondered what all the struggles were for, now that it felt like we simply adapted to the legal changes rather than bringing them about. Whatever the law now, it certainly couldn't rectify the past. In fact, seventeen years have passed since Section 171 was repealed, and it has had little positive effect on the present, a present in which still only a

handful of us are visible. I didn't want to talk about the past, nor did I want to deliberate over the politics of the present. In light of what was happening to Jay right now, I had a burning desire to talk about, to experience, to feel something different. I felt different. As if someone had hit a switch and there was no going back. Life is finite. That much was now clear.

The waitress brought our drinks on a tray that was like a bouquet of fragrances: coffee, beer and ouzo, whisked with our cigarette smoke. A couple of kids walked past our table eating ice cream. The littlest one was struggling with his strawberry sorbet, which was melting down the cone as he slurped faster and faster. I noticed his fingers, syrupy, small, locked around the cornet like a clamp, a clutch that is at once firm yet slack enough so as not to break the cone. What a focused grip children have. This happening unexpectedly stirred me, as if the jouissance of this child cracked open an altogether different present. My senses became engrossed in this event, my nose bewitched by the aroma of strawberries long after he had walked past us. I could fully apprehend the child's urgency, his attentiveness to the melting ice cream. The idea of being so completely in the present moment, in total communion with one's body, filled me with a profound sense of joy. I wanted to experience that relish first-hand, once again, as if I weren't too old for it. As if the reflexive self-consciousness that divided me from the world, that divided my body from my mind, those necessary reflexes for survival against a society that had alienated me from my own flesh, at such a young age that it took so many years to recover the union, as if those severances had finally been restored.

Being young had nothing to do with age; it was the ability to attend to the nowness of experience. To walk around the streets with the perfect illusion of safety. To inhabit nature and your surroundings wholly, free from all the anxieties that plague one's entry into conformity; a compliance that comes with the pursuit of a life less precarious. It is curious how much fear crops up with the first sense of stability. As if stability introduces fear, the fear of losing the very little that you have come to understand as security.

I remembered the strawberries from that morning. The first bite, the consistency of fluffy saccharine in my mouth, exploding with the sweet scents of their juices into my nostrils. The contrast between those freshly-picked strawberries and the smell of full-bodied filter coffee. The absolute indulgence of smoking on that balcony, wearing her organic cotton t-shirt from Hermès, my bare feet on clean tiles, the bathroom products that recoiled in corners as if they were ashamed of their price. The bathrobe she draped on my shoulder when I came out of the shower, a softness that was recognisable but not habitual — the last time I experienced something so lush was probably when Grandma was still around, and she would wrap me in Leila's towels. A mattress made for intergalactic journeys on the set of a very earthly, too earthly, almost-paid-off-my-mortgage type of earthly flat.

I made my excuses to the group; said I needed an early night, and a walk to clear my head. I strolled down the high street, through the little neighbourhoods, past the bars, houses, schools, churches, trees, concrete, the town square. Everything was so familiar I could notice

the most minute changes: an additional lamp post, the unlikely installation of a bench in a park, never-ending roadworks that led occasionally to more uneven roads, listed buildings that each year seemed more derelict, with missing stones, broken windows, loose latches, rickety roofs. I could smell the end of the summer in the air. When the summer was over, the year was over, and so every September marked a new beginning for those of us who left again. I have often felt that I live for the sensation produced in the transitional space which extends from mourning the pleasures that have come to an end to inhabiting the novel space of possibility, of something new and unknown. September just expands across that temporal and liminal space of action, with all the new and unpredictable beginnings that it could materialise. Over an hour had passed. I was outside her flat. Uninvited.

'Good evening. Did you forget something?' she said, teasing me but pleasantly surprised.

'I could smell the fish baking in your flat all the way from the city centre,' I said, testing the waters.

'I have a thing for hungry stray cats looking for a home. Come on in.'

She pulled me inside by the wrist, closed the door behind me, pressed me against the wall and gave me a kiss so welcoming that I felt that I had lived in this same flat in some other lifetime — a happy one. She tended to the sea bream, to the salad, the *tsakistes* (*cracked green olives*), to the tea light candles, and poured me a drink without my asking for one. It was an effervescent multivitamin. I laughed out loud and so did she. I helped with the salad and laid the table. She told me about

her day at work and I told her about my cancer-related missions with Jay. We sat down to eat. She was casual, civilised, warm, affectionate, attentive; she was actually romantic. This person seemed drastically different from the one that I had been seeing on and off for half a year. Was she different or had something else changed? Was it me? Maybe I was just exhausted from being so combative, and I tried to allow myself to relax into the atmosphere. I slid the balcony window further open; it was still warm and humid. I asked her if we should move to the table outside, to catch the gentle breeze. She said casually, 'Oh, are you hot? We can switch on the aircon.' I told her that I'm not really a fan of air-conditioning, that it's just nicer outside on her large balcony, and that we could light lots of the big candles too. She hesitated and this prompted my confusion. Once again, I was trying to diagnose a situation based on her behaviour.

'What's wrong with this balcony?' I caught myself thinking, but then realised that I'd said it out loud.

'The neighbours,' she replied. 'There's a colleague who lives on the same floor, in the building across from here, and he can pretty much see most of my flat. That's why I pulled down the blinds in this corner of the living room.'

I was still a little perplexed and, despite her nonchalance, I just found it difficult to believe her. 'Well, it's not like he can see your bedroom. We are just having dinner, it's not a big deal.'

It was a big deal. For both of us. We were not equal, at least not in the real world. In the real world she had power, a power that required her to abide by the rules that Jay and I broke, the very rules that almost

broke us. To some extent, she wanted and tried to give me everything she believed I needed. Or at least, she certainly dreamt about it. During our hook-ups, there were a handful of nights when she would talk in her sleep, while I stayed up reading about global horrors or local corruption. I would hear her muttering about the things she wanted to shower me with, how much I meant to her and all the effort she was willing to put into pleasing me, to being with me. I would examine her, trying to decode what she was saying, and whether she was really asleep. I grew tired on her behalf. We were so different in this respect. I rarely dreamt, and when I did it was usually a nightmare depicting agonising and gruesome situations. I learnt to interpret the feelings in my dreams more than the symbolism, because I had spent so many years decoding meaning from a culture saturated with outrageous, yet conventionally acceptable, signifiers. It was as if sleeping provided the space to pay attention to the feelings that I couldn't process during the day, because my mind would so often be in overdrive, either from over-working or surviving, or over-working to survive. Dreaming, for me, happened in waking life, often with Jay: we dreamt of all the things we would one day do, and all the places we would go. In recent years, with a lot of labour, I have tried to materialise those dreams more than I have dreamt.

But here I was, well fed and well sexed, in bed next to someone who couldn't communicate either emotions or desire in waking life, to such an extent that they leaked out of her body in the form of a nocturnal somniloquy. We ate the fish, had a strained discussion about the balcony, then I initiated sex because I thought it a better

option than arguing. She fell asleep instantly, and only a few minutes later I heard her mumble, 'I want you to stay here, forever… this is our home.' Experiencing her body in such conflict kept me in a pensive and insomniac state for hours. The contradiction, between the person I woke up to and the one who slept beside me, spiralled into a play of shadows that overshadowed any possibility of trust.

I felt a compulsion to call Jay. I tiptoed out to the balcony and dialled her number. She answered instantly.

'I didn't think you would pick up,' I said softly.

'We had sex, I made sure I came first, he then came in five minutes and fell asleep straight away. I'm trying to figure out his PlayStation. Wanna come round?'

'Jay, seriously…' I said, smiling at the thought. I felt like I had so much to tell her that I didn't know where to begin. I called her because I wanted to hear her voice, to make sure that she was alright. Actually, I called her because I wanted to make sure that *I* was alright.

'I can hear that brain of yours short-circuiting over the phone. What's going on? Is she giving you grief again? You know you'll forget about her in a heartbeat when we go back to London after the surgery,' Jay said, in her usual unvarnished way, in specifically the way that I need to hear when I'm feeling a bit stuck.

'It's not about her…' I replied, but I wasn't quite sure how to say it and just held the phone in silence.

'What is it? Spit it out already. You're acting weird. You never talk like that.'

'Jay, I'm scared,' I blurted out.

'You're being ridiculous. After everything we've been through? A little cancer is going to scare you?'

That morning I told the lover that she talked in her sleep. She asked me, in alarm, 'and what did I tell you?'

I thought this an interesting question. She could have asked, 'What was I saying?' but she didn't. She asked, 'What did I tell you?' a question that suggests a telling, a confession of some sort. She sensed that she had unwittingly revealed that she was more overpowered by our affair than she had the courage to admit. As she asked the question, she busied herself making fried eggs and toast, and avoided looking at me. I noticed the vein in her neck throbbing in anticipation. This vein had betrayed her many times in our brief but intense affair. I decided to lie.

'You were telling me how turned on you were and that you loved my ass. I thought you wanted to have sex again, but I realised that you were actually asleep.'

She smiled at the eggs and said, 'I probably did want to have sex. Do you want to have a threesome with my ex-boyfriend? He's really hot.'

I stared at her in disbelief, while she continued flipping the burning oil onto the eggs. Everyone knew, because everyone always knows on such a small island, that the "ex-boyfriend" was a front, for the journalists, her family, the obligatory weddings and social occasions she had to attend. Pambos had also been hooking up with her "ex-boyfriend" on and off for the last couple of years, until he got fed up with the whole charade.

'You want to have a threesome with me and your ex-boyfriend?' I repeated, just to make sure that I had really caught her tone.

'Yeah, why not? You've had plenty of those right? I mean, it's all about sex for you isn't it?' In the quick

glance she stole at me, I couldn't tell if she had a smirk on her face or if she was serious. This made me defensive right away.

'But we are already having a threesome darling… we are having a ménage à trois with your ego,' I said insolently, and, picking up my bag, made my way to the door. She hopped in front of me and tried to stop me. She looked a little pleased with herself and how she had managed to irritate me. She tried to prevent me from leaving, telling me that I was overreacting, that she didn't think that someone like me ("someone like me" clearly means slut in this context) would be such a prude when it came to threesomes. I put my bag down, removed my sunglasses and, looking straight into her eyes, I said, 'Call him now. Go on. Get your phone. Now. Tell him to be here at 7 pm tonight and let him know that we will be fucking on your balcony in full view of all your neighbours. Otherwise, we don't fuck at all.' No, we were not equal, at least not in the real world. In the real world she had power; I had freedom.

We had spent most of that summer barely speaking, unless it was during sex. I did the speaking; she did the sex. From our time together, I remember her balcony the most vividly. It frightens me how easily that memory stirs up my emotions. It caught the sun at a specific angle and, depending on what time of day you were there, it produced a distinct smell. At midday this was a mixture of dust and asphalt that would seep into the living room. In the late afternoon she would water the plants, and a particular odour emanated from the tiles. Scorched by the heat, those tiles seemed to absorb and expel the overflowed water into a mist that was redolent of clean

earth and the subtle fragrance of pine antiseptic floor cleaner. The evenings carried the scents of the few trees and plants surrounding her building, along with the various foods being prepared in the apartments around us. As it grew darker, all these smells mellowed into an aroma that I can't exactly describe in olfactory terms, but if I had to somehow try to capture it as a sensation, then it would culminate in one word, with all the scented universes that blossom with that word: home.

Here were all the material effects of a person who came from a family with little to offer by way of emotional support, but much more to offer by way of financial investment. They ensured that she went to an expensive university abroad, and would come back to set up a predictable career as a corporate lawyer in the family firm. Her profession was simply given to her, and that guaranteed that everything else would be a given. Her car was purchased from the family-friend car dealer. Her apartment was a new-build in a complex where her family had bought three flats: one for her, one for her brother, and an extra flat for his children. This person was given a career, one that she professed to enjoy, one that made her wake up before her alarm, occasionally with so much anxiety that her body, immobile and short of breath, would wake me too. A person who had regular responsibilities like escorting her mother to church on Sunday, or babysitting her brother's spoilt children while he was visiting Ukraine "for his scoliosis", when it was clear that it was for sex tourism. She had normal hobbies too, but somehow these hobbies required big budgets, for the right gear and top-of-the-range technology. She had typical neighbours, neighbours who owned their

houses, the forever type of neighbours who, no matter what corrupt activities they engaged in, had no fear that they would be evicted from their homes. This closeness to someone else's life, a life with no urgency, no cancer, no struggle, no danger, awakened in me a desire to anchor myself in something or someone; when the one who really mattered the most to me could be slipping out of my world. Yes, on the surface, this lover displayed all the semiotics of a stable, secure and "normal" life, and, in the absence of anything else that felt stable in my own life, I latched onto the semiotics.

After our fraught discussion that morning, she went to work and left me her Visa card on the table in case I, or the house, needed anything. Houses are needy things. I took a shower and, picking up one of her shampoo bottles, I noticed the tiny sticker on the side that read '€42.69'. I laughed. What on earth am I doing here? I called Jay and we made another plan. Treatment in London, that city we occasionally called home, might be better for people like us. She agreed. I used the Visa and booked our flights to Heathrow the same day, first-class. I made sure not to leave any trace of me in her flat and, as I was about to shut the door behind me, I returned to the kitchen counter and left her a note: 'More than I want a home, I want to be free.'

Author's acknowledgements

Natalia Damigou-Papoti has shaped every single word of this book from its inception, with developmental guidance that had me chiselling paragraphs for weeks on end. Bridget Penney has been this writer's editorial dream. Dialogical and erudite, I've been immensely fortunate to have her time, feedback, encouragement and support. Lizzie Homersham kept this project on track for two entire years and offered valuable editorial input. Eleanor Sawbridge Burton provided sharp copyediting and comma fever that polished the final draft. And there is Martin Thom who proofread early versions of three of these stories. Also, can we all agree that Book Works is a rare diamond in the publishing world?

Writing requires all sorts of people and offerings. So many have laboured to ensure that these two years have been balanced during times when both local and global events have further fragmented our already difficult lives. With Mihalis Intzieyanni we shared wild fantasies of photography and its (queer) futures, as well as the decadent oral joys of Cypriot dialect (many of which made it into this book). I am grateful for Inara Jaunzeme's and Jan Roth's enduring friendship and the German input. Panagiotis Poimenidis and Phillip Prokopiou whose photographs have layered our connection(s) over the last decade. Drago Krystev supplied bread, butter and care — a staple diet for starving creatives. Lucia Farinati was always listening. Grahovac waxed the Serbian swearing (she has other talents too). The Constantinou clan has been the only stability that this orphan has known and I forgive them for infecting us with the virus. The fellow migrants at Queen's Road (Vangelis, Eftihios, Cooper, Lima) made the pandemic a collective radical project with many moments of love, care and joy. This novel is also dedicated to the sluts, faggots and addicts that keep me alive and embodied. I wouldn't have made it this far had it not been for the lesbian sisterhood in Cyprus who ensure that I am both grounded and elevated, dreaming of the coming feminist insurrection that on one hot day in August, will make the island sound with the sirens of a revolution with no backwards glance.

Other Reflexes
by Diana Georgiou
Interstices No. 2

Published and distributed by Book Works, London
© Diana Georgiou, 2022

ISBN 978 1 912570 15 7

Commissioning editor: Bridget Penney
Proofread by Eleanor Sawbridge Burton
Designed by James Langdon
Cover art by Tatjana Stürmer
Typeset in Janson and Passio Graphis
Printed by die Keure, Bruges

Book Works
19 Holywell Row, London EC2A 4JB
www.bookworks.org.uk
Tel. +44 (0)20 7247 2203

Book Works is funded by Arts Council England